CAROLINE DURIEUX
Lithographs

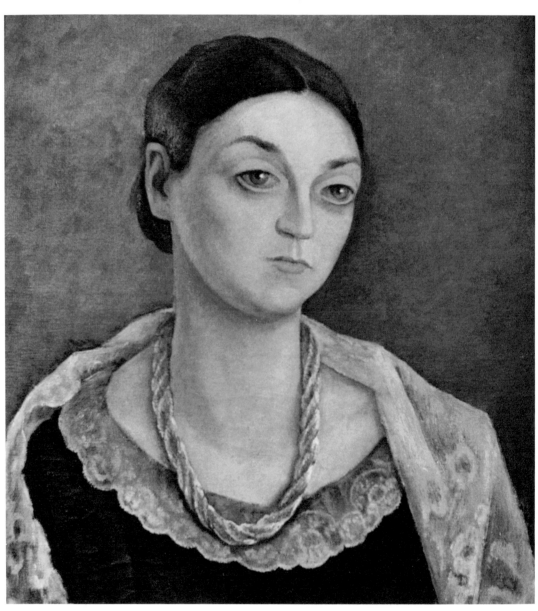

Portrait of Caroline Durieux by Diego Rivera, 1929

CAROLINE DURIEUX

LITHOGRAPHS OF THE THIRTIES AND FORTIES

Text by Richard Cox

Louisiana State University Press / Baton Rouge and London

Copyright © 1977 by Louisiana State University Press
All rights reserved
Manufactured in the United States of America
Designer: Albert Crochet
Type face: VIP Palatino
Typesetter: Moran Industries, Inc., Baton Rouge, Louisiana
Printer: Meriden Gravure Company, Meriden, Connecticut
Binder: Kingsport Press, Inc., Kingsport, Tennessee

For Diana and Paul Durieux

Contents

Plates I Latin America

1 *Art Class*, 1942. 10½" x 8½". Edition of 10. Louisiana State Library.

2 *Benediction*, 1932. 9" x 6½". Edition of 10. Louisiana State Library.

3 *Priests*, 1932. 10⅝" x 14". Edition of 10. Anglo-American Musuem, Louisiana State University.

4 *Acapulco*, 1932. 9" x 10¾". Edition of 10. Louisiana State Library.

5 *Good Story*, 1932. 9" x 8½". Edition of 10. Louisiana State Library.

6 *Three Cats*, 1932. 10¾" x 13½". Edition of 10. Louisiana State Library.

7 *Boredom*, 1942. Present whereabouts unknown. Reproduced in *Caroline Durieux 43 Lithographs & Drawings* (Louisiana State University Press, 1948).

8 *Dressmaking*, 1932. 16½" x 11¼". Edition of 10. Anglo-American Museum, Louisiana State University.

9 *Teatro Lirico*, 1932. 11" x 13". Edition of 10. Collection of Dr. and Mrs. John F. Christman, New Orleans.

10 *Golfer*, 1932. 13½" x 9". Edition of 10. Louisiana State Library.

11 *Bipeds Dancing*, 1932. 8" x 8⅝". Edition of 10. Louisiana State University.

12 *Dancing with Vigor*, 1932. 8¼" x 7¼". Edition of 10. Louisiana State Library.

13 *Fish*, 1936. 11" x 14½". Edition of 10. Louisiana State Library.

14 *Preview*, 1916. 13½" x 18". Edition of 10. Louisiana State Library.

15 *Nice Men*, 1936. 13¼" x 14½". Edition of 10. Museum of Modern Art, New York.

16 *Nice Women*, 1936. 11¾" x 16". Edition of 10. Louisiana State Library.

17 *Rugged Americans*, 1936. 13″ x 13½″. Edition of 10. Louisiana State
 Library.

18 *Playboys*, 1936. 15½″ x 14″. Edition of 10. Louisiana State Library.

19 *Park in Rio*, 1942. 12¾″ x 8½″. Edition of 12. Louisiana State Library.

20 *Spectators*, *ca*. 1940. 10⅜″ x 8⅜″. Edition of 12. Louisiana State Library.

21 *Los Diplomaticos*, 1942. 10½″ x 7¾″. Edition of 10. Louisiana State
 Library.

II The New Orleans Subjects

22 *The Beggar*, *ca*. 1933. Collection of Mr. and Mrs. Charles Durieux,
 Arlington, Virginia.

23 *Plantation Garden*, 1946. 10¾″ x 7½″. Edition of 20. Louisiana State
 Library.

24 *Commencement*, 1947. 11½″ x 9½″. Edition of 20. Louisiana State
 Library.

25 *Academic Portrait*, 1940. 13″ x 8⅜″. Edition of 12. Louisiana State Library.

26 *Founders Day*, 1942. 11¾″ x 7″. Edition of 12. Louisiana State Library.

27 *Nuns Walking*, 1945. 17″ x 11⅜″. Edition of 20. Louisiana State Library.

28 *First Communion*, 1944. 11½″ x 8½″. Edition of 20. Louisiana State
 Library.

29 *Bourbon Street—New Orleans*, 1942. 10⅝″ x 10″. Edition of 10. Library of
 Congress, Washington, D.C.

30 *Taxidermy*, 1946. 8″ x 5″. Edition of 15. Louisiana State Library.

31 *Loneliness*, 1942. 11″ x 8½″. Edition of 10. Louisiana State Library.

49 *The Meeting of Comus and Rex (Comus Ball)*, 1946. 11″ x 8¼″. Edition of 10. New York Public Library.

III The Tragic Spirit

50 *Persuasion*, 1948. 8⅛″ x 5⅛″. Edition of 15. Louisiana State Library.

51 *Fear*, 1947. 7″ x 7″. Edition of 15. Anglo-American Museum, Louisiana State University.

52 *Exile*, 1939. 10½″ x 9″. Edition of 12. Louisiana State Library.

53 *Oppression*, 1942. 13″ x 8½″. Edition of 12. Louisiana State Library.

54 *Survivor*, 1948. 11¼″ x 9″. Edition of 10. Louisiana State Library.

55 *Desirée*, 1947. 12¾″ x 9½″. Edition of 20. Louisiana State Library.

56 *Children*, 1945. 8¼″ x 7¾″. Edition of 8. Louisiana State Library.

57 *The Visitor*, ca. 1944. 14¼″ x 7¾″. Edition of 10. Library of Congress, Washington, D.C.

58 *Tomorrow*, 1948. 8″ x 5½″. Edition of 20. Louisiana State Library.

CAROLINE DURIEUX
Lithographs

Introduction

The 1930s and 1940s have bequeathed us a mixture of American artists: angry protest painters and printmakers who denounced fascism and labor injustice, regionalist artists who celebrated the history and folklore of America, and various abstract painters who struggled for recognition at a time when cubism, futurism, and other European-born modern movements came under shrill attack by chauvinist American critics. Social unrest and a mounting sense that war, depression, and totalitarian governments had enfeebled human progress spurred the growth of satire in the 1932–1948 period. Grant Wood, Peggy Bacon, Reginald Marsh, Adolf Dehn, and a host of other satirists put under a microscope the religious quirks, political excesses, and social fads and follies of Americans. Caroline Wogan Durieux, born and raised in New Orleans, is one of the best graphic satirists of the Depression–World War II age and would have been more prominent had she worked out of the art nerve-center, New York City. Operating in the South, Durieux ranged herself against the pomp of high New Orleans society, the studied solemnity of Louisiana academics, and pious airs of priests and nuns. She ventured into Mexico, Chile, Uruguay, and Brazil for jibes at diplomats, North American businessmen, and the up-and-coming Latin American bourgeoisie.

Durieux's lithographs are a blend of realism, symbolism, and her own personality. She only slightly caricatured her victims. Specific people and incidents that she witnessed firsthand in

New Orleans and in Latin America were rendered with little embellishment. At the same time, these sardonic views of diplomats, priests, society women, salesmen, and nightclub singers transcend simple portraiture or genre and become emblems of the fragile human condition in modern times. Satirists must have formidable egos—be able to dish it out as well as take it—and Caroline Durieux measured up here. Few have dared lock horns with her, and a quiet self-assurance and skeptical mind played a major part in the dynamics of her satire which is not always fair and impartial. Good satire seldom is. These lithographs of the thirties and forties are not picturesque vignettes of Louisiana society by a local lady artist. They are bittersweet and often pessimitic evaluations of people and events, clearly the product of a worldly artist. She was too aloof from her subjects to be sentimental.

The ability to laugh at oneself and the world in general were inherent virtues in the New Orleans Creole community that Caroline Wogan Durieux grew up in just after the turn of the century. Descended from Irish-French parents who were both fiercely independent and who believed in hard work and a good time, Caroline learned to challange authority—quietly, in subtle ways. In keeping with the French tradition of noblesse oblige, "outright confrontation with parents, teachers, and the clergy in this society was forbidden," she remembers. "I could not speak out against, but I could draw their pre-

tensions."[1] Indeed, her childhood caricatures of the extended Wogan-Spelman family and friends living on Esplanade Avenue were well received. Caroline was the only artist to emerge from this Creole background. She was drawing obsessively before starting grade school, and at twelve she swapped the obligatory piano lessons for art lessons which were not easy to find in those days. Over the next seven years she would wheedle her parents for advanced art training at every turn. It was a rare commitment for a woman artist in a day of severe discrimination against women in this profession. Even with their reservations about its practicality, Charles and Anna Wogan consented to Caroline's wishes to study art at Sophie Newcomb College in 1913.

At Newcomb, she studied under Ellsworth Woodward, a prominent local artist best known for his pine tree landscapes and picturesque views of the French Quarter. The training was nineteenth-century German academic. Students drew mostly from casts, spent hours working out perspective systems (see figure 1), and painted (decent, realistic subjects) only after mastering drawing. They were generally expected to produce works closely allied to the style of Woodward himself. Long hours at the drawing table did not daunt Caroline—she never shied away from the disciplines of draftsmanship, as those students who studied under

1. Interview, Caroline Durieux, Baton Rouge, La., April 30, 1977.

her in the Louisiana State University art department will attest. Less appealing was Woodward's stiff manner and conservative doctrines. Art was a high and serious endeavor, he intoned, intended for enlightenment or genteel diversion, but never to be debased by outbursts of comedy. This produced some strain between Woodward and his prize pupil, Caroline Wogan, who already considered herself a satirist. She did not have it in her to be a good disciple. She sized up Woodward's strengths and weaknesses as she had the authority figures from her Creole neighborhood, quietly sifting through his notions, accepting the demand for solid craftsmanship and rejecting his overall aesthetic theories.

Much of her education took place outside the art department. As a liberal arts college, Newcomb exposed students to history, economics, political theory, and literature. Thorstein Veblen's, *Theory of the Leisure Class*, with its impassioned, wide-ranging arguments for reform in politics and society, particularly moved Caroline as did the general enthusiasm for progressive reform in the 1912–1917 era of Woodrow Wilson, Theodore Roosevelt, and Eugene Debs. Although she spent an occasional vacation in New York visiting her mother's family, she was not familiar with the art scene there. Nevertheless she moved intellectually on a parallel path with such Ash Can artists as John Sloan and George Bellows, whose socially conscious art was energized by the active Progressive–Socialist movements of that day.[2]

The 1910–1917 period was also rich in artistic ferment, as most of the pivotal early modernists, Picasso, Kandinski, Mondrian, Nolde, Malevich, and Duchamp explored the far frontiers of abstraction. The rowdy New York Armory Show of 1913, which was fanned by much newspaper ballyhoo and by the theatrical presence of Teddy Roosevelt acting as roughrider critic, brought the new European painters to the attention of American audiences. American artists scurried to get in step with the new ideas and styles of the French, Italian, and Russian artists. Not a breath of this reached Caroline at Newcomb. In 1913 New Orleans was, of course, a fabulous city, cosmopolitan and multilingual, daring in its food, drink, music, and freewheeling life-style. But as an art center it did not rival Boston, Chicago, or Philadelphia, not to mention New York. New Orleans art galleries were few and far between, and those that did exist were indifferent to modern art. Local art publications did not exist. The Delgado Museum (now the New Orleans Museum of Art) had no modern paintings or prints of note. The Vieux Carré would not become a thriving bohemian center for artists and writers until the 1920s when William Faulkner, Sherwood Anderson, Lyle Saxon, William Spratling, George "Pop" Hart, and others moved in. Prior to 1918 it was a "slum" (albeit an elegant one), without exhibition galleries, garret studios or even the itiner-

2. For a good general account of Sloan, Bellows, and the Ash Can school of painting, see Milton Brown, *American Painting from the Armory Show to the Depression* (Princeton, N.J.: Princeton University Press, 1955), 3–47.

ant portrait painters who have perennially enticed tourists in front of Jackson Square.[3] Hostile to the new styles, Woodward considered James McNeil Whistler to be avant garde, and he discouraged his students from exploring the ideas of the new European wave. Contrary to these admonitions, Caroline often visited the home of Hunt Henderson, a friend of her family, to see his private collection of paintings by Renoir, Degas, Sisley, and Cézanne. But there were no other fired-up art students to talk to about these works, to share the excitement with—no follow-up discussion that is necessary to a good art education.

Only after she entered the Philadelphia Academy of Art in 1917 did Caroline Wogan grasp the enormity of the modern art revolution. Her New Iberia friend Weeks Hall, who was studying at the Pennsylvania Academy of Fine Arts, encourage her to apply to the academy, and with the money originally set aside for her debut plus a scholarship from the academy, she entered this venerable art school for graduate work after finishing her studies at Newcomb in 1917. In its museums, libraries, proximity to New York, and classrooms of activist students, Philadelphia was a godsend for the young Creole student. Henry McCarter, a close follower and enthusiast of French Impressionism, took Caroline under his wing at the academy. No less a taskmaster than Woodward, he was, nonetheless, more tolerant than the New Orleans teacher. Instead of serving his own manner up as an absolute model, McCarter sent struggling

students off to the museums and libraries to study the drawings of Delacroix, Cézanne, and Hokusai. On one such extended research venture, Caroline steeped herself in the Chinese landscape painters, carefully considering their economical line and ability to say more with less, which would become her own trademark later on. She studied and greatly admired Eakins, Cézanne, and Van Gogh, although they did not directly affect her own style. Honoré Daumier's lithographs published in *La Caricatura* also came to her attention, and the great French satirist would remain the most powerful influence on her own lithography through the coming years.

After eighteen months of study in Philadelphia, Caroline Wogan returned home and married Pierre Durieux, a childhood friend and New Orleans exporter. The Durieuxs spent the first half of the 1920s in Cuba before moving on to Mexico City in 1926 when Pierre was named the Mexico representative for General Motors. They returned to New Orleans in 1936 where Caroline taught art at Newcomb and headed the Federal Arts Project in Louisiana. In 1942 she joined the art faculty of Louisiana State University in Baton Rouge.

Caroline did not learn the art of lithography at Newcomb College or at the Pennsylvania Academy of Fine Arts. Stigmatized as a minor art,

3. See Lyle Saxon, *The Friends of Joe Gilmore* and Edward Dreyer, *Some Friends of Lyle Saxon* (New York: Hastings House, 1948), 132–37. See also Carl Zigrosser's introduction to Caroline Durieux in Zigrosser, *The Artist in America* (New York: A. A. Knopf, 1942), 3–47, 125–26.

6

printmaking was a rare offering at academies in those days when painting and sculpture were *the* art curricula. In Cuba and for a short time in Mexico, Caroline painted still lifes, landscapes, portraits, and a few satirical studies, but as she recalls, "I always had a preference, a special feel for the black and white medium." And for satire, which she slowly came to realize was her strong suit and which worked better for her in drawings and prints. "Color takes a little strength from satire," she once said.[4]

It was her drawings that impressed Carl Zigrosser, director of the Weyhe Gallery in New York and one of America's leading experts on prints. In 1930 Zigrosser talked Durieux (who was temporarily staying in New York) into trying lithography just as he had steered other bright talents like Howard Cook, Adolf Dehn, and Wanda Gag toward printmaking. As a multiple medium, of course, lithographs can be printed in quantity, making for a wider audience and more communication, which nearly always concerns the social satirist. One of New York's premier printers, George Miller, who had printed stones and plates for John Sloan and Edward Hopper, showed Caroline the rudiments of the lithographic process: how to draw with the pencil and crayon on the stone, how to scrape areas for alteration and texture, and how to prepare the stone for printing. From Howard Cook she also learned the technique of etching but immediately took a preference for the direct lithographic process where "you can see exactly what you are doing throughout."[5]

Lithography was the printmaking method closest to drawing. She never, however, drew on transfer paper and handed these sheets over to the printer to work up on the stone as many nineteenth-century "lithographers," including Whistler, had done. She worked directly on the stone.

Back in Mexico City she found it difficult to find a printer and to obtain the heavy Italian paper she wanted. The Mexican artists had just begun to work in prints after a decade of mural painting, and Durieux by 1931 had not yet met Orozco who was producing lithographs and might have helped her get started. Finally she located Dario Mejia who worked at the Senefelder Lithographic House in Mexico City and with him she worked on her first set of lithographs, the Mexican Series in 1932. Having taken great care in composing her images, Caroline wanted to be directly involved in the printing process, but exercising time-honored Latin *machisimo*, Mejia would not permit Caroline to assist in the actual printing: one look at the 5 foot 3 inch artist told him she should not concern herself with man's labor of lifting stones and rotating the giant wheels of the press. (Years later, after moving to Baton Rouge, she could take over this final step of the lithographic process in her Louisiana subjects). Fortunately, Mejia proved to be a master printer, and Caroline had no objections to the printing quality of the Mexican Series. Eleven lithographs of a

4. Interview, Caroline Durieux, April 30, 1977.
5. *Ibid*.

small edition (ten), signed in pencil, were completed at the Senefelder company, and were shown at her first one-man exhibit in 1934. Durieux sent Zigrosser one print of each of the Mexican Series lithographs in gratitude for his earlier encouragement. The Mexican artists and American intellectuals in Mexico City reacted enthusiastically to the prints, although the artist's family in New Orleans regarded this turn to biting satire as "unfortunate" and "unbecoming" for a New Orleans lady. Caroline produced small editions not to drive up the prices of the individual prints, but only because "ten prints were all I thought I could possibly sell."[6] She produced five more lithographs in 1936, titled the North American Series, and several dozen more after returning to New Orleans in late 1936. These stones were all sent to New York for George Miller to print.

From the time of conception to the lifting of the print off the press, Caroline Durieux proceeded deliberately. Typically, she would be walking about Mexico City or New Orleans alert to nuances of human dress and behavior. Something incongruous or absurd would catch her eye, she would take mental note, draw a rough sketch after she got home, and file it away to be turned into a lithograph soon thereafter—or it might be years before the memory or sketch became a lithograph. One 1942 print, *Boredom*, grew from a sketch that the artist made of two women playing cards in a Havana apartment back in the early 1920s. A strong visual memory served her well. Unlike Henri Toulouse-Lautrec,

who sketched constantly in public, drawing attention to himself with his ever active pencils and brushes, Caroline Durieux just watched, her eyes bearing in on idiosyncracies of behavior that would not be forgotten. She worked long hours on the stone, wedding a finisse of execution to a pictorial shorthand. Her titles were generally afterthoughts but not unimportant. "The titles are intended to aid the intelligent observer. Direct communication of my ideas does not frighten me," she says.[7] Her satire can be playful or stinging but rarely cruel, and it is never inflated in the style of the British caricaturists, Gillray and Rowlandson. She had a sharp pencil but not a wounding manner. Durieux's satires are of particular people, middle-class and upper-middle-class citizens for the most part in specific places and contemporary time. These pictures contain full, authentic reports on human experience. They are explicit, readable, clear, direct.

6. *Ibid.*
7. *Ibid.*

I

Latin America

Caroline Wogan's marriage to Pierre Durieux brought unexpected travel opportunities for the young artist. Pierre spoke fluent Spanish and French which was essential to his export business and his post with General Motors in Cuba and Mexico City. Pierre and Caroline also traveled widely throughout South America. Life for a businessman's wife is often lonely; but it was not so for Caroline; it was not Pierre's life she was forced to live. He encouraged her art passions and imposed few demands on her as social hostess—the bane of many a businessman's wife stationed abroad. As lush and exotic as Cuba was in the 1920s, it somewhat frustrated Caroline who found art supplies, contacts with other painters, and outlets for her art scarce in Havana. Thus, her satirical gifts were slow to bear fruit. Of course, she spent a major share of her time in Cuba raising her son, Charles, and she painted some landscapes and flower studies when time permitted. Circumstances did not allow her to develop her full potential during the 1920s. Still, she possessed a fundamental confidence in her own talent that often sustains an artist in lean years. When Pierre was transferred to Mexico City in 1926, the art picture brightened for her.

In the late 1920s, Mexico City had a booming art culture, activated and partly financed by the Mexican Revolutionary government. Mural paintings of Mayan-Aztec history and mythology, the evils of the long Spanish occupation, and the heroics of contemporary history spread across the walls of public buildings all over the

city. Their creators, Diego Rivera, José Orozco, David Siquieros, and other artists were rightly being hailed as the most innovative Western Hemisphere artists of that day, and many United States painters and writers flocked to Mexico City to catch firsthand this renaissance of culture and politics. Mexico was in vogue, as it would again become during the 1968 Olympic Games. Through René d'Harnancourt, who later became curator of the Museum of Modern Art in New York, Caroline met Orozco, Siquieros, and Rivera. The latter was particularly taken with the young New Orleans artist, agreed to paint her portrait, and praised her paintings in Mexican newspapers:

> Because of the fine plastic quality of her work, its delightful color and acute drawing, Caroline Durieux has brought la peinture mondaine back to the position of importance it once occupied. Not since the eighteenth century, perhaps, have such social chronicles been so ably put on canvas. The delicious satirical qualities of her painting do not, however, make it "literary" nor does the satire detract from the plastic quality of her work. Her pointed and politely cruel persiflage is after all a motive, a pretext, for constructing pictures distinctive in color and keenly caustic in line. Both Raeburn and Toulouse Lautrec would have appreciated them.[1]

American artists swarmed about Mexico during the late 1920s and early 1930s, drawn to the active art scene, exotic subjects, and incredibly cheap living conditions. Most painted picturesque scenes of Indian peasants or aped the heated rhetoric of the more politically oriented Mexican muralists. Durieux never felt the urge to climb up on the scaffold and paint a mural, and she did not choose to depict the struggle of the noble peons carrying centuries of Spanish oppression on their backs. "Coming out of a comfortable New Orleans background, how could I presume to express the passions and tragedies of the Mexican Revolution?" she exclaimed. But she did not feel out of line depicting the Mexican nouveau riche, members of the rising bourgeoisie. It did not take her long to realize that the class-conscious pretenses and material mania of the Mexican bourgeoisie differed little in spirit from the middle-class patterns of people she had long scrutinized back in New Orleans. In her own pithy words: "What marks the bourgeoisie everywhere is *what they own*."[2]

Hers is not brass-knuckle satire. Sometimes her observations are almost factual and endearing as in *Benediction*, 1932 (figure 2), a small lithograph of a *pobrecito* Indian priest performing the mass in a tiny, primitive Taxco church. *Benediction*, as Durieux recalls, "was my first lithograph of the Mexican Series and revealed my uncertainty with the medium. I had to do it over twice since I did not realize that the image printed in reverse. When it came off the press, I gasped, 'O Dios Mio!, the priest is giving the benediction with the wrong hand!'"[3] Technical difficulties aside, the print affirms the sad, serious nature of the Mexican Indians and in no way did the artist mock their solemnity. But nei-

1. Diego Rivera, quoted in Zigrosser, *The Artist in America*, 127–28.
2. Interview, Caroline Durieux, April 30, 1977.
3. *Ibid*.

ther did she choose to romanticize the Indians' long suffering burden as Orozco had done in his murals. In *Benediction*, the priest is not an archetype or heroic figure of history, merely a simple churchman, carrying on as best he can in modest circumstances. He offers a contrast to the fast-striding cocksure clergyman of *Priests* (figure 3), which shows four Chilean priests winging through the streets of Santiago, where Caroline once visited with her husband. In Mexico, owing to the strong anticlerical feeling born out of the political revolution, the priests and nuns kept a low profile, but in Chile, where the Church's dominant social-political position remained intact, the clergy was much more assertive.

The Mexican bourgeoisie felt the sting of Durieux's wit in five razor-sharp satires, *Acapulco* (figure 4), *Good Story* (figure 5), *Three Cats* (figure 6), *Boredom* (figure 7), and *Dressmaking* (figure 8), all produced in 1932. *Acapulco* presents an Amazonian woman alone with her boyfriend or husband on a deserted Acapulco beach (at a time when there was such a thing). Again, the artist does not intend to celebrate this Mexican as a heroic revolutionary figure: she was simply born with this ample body that seems ready to burst free of her bathing suit at any moment. This comic situation is accentuated by the background presence of the spindly boyfriend who, dressed in a roguish slit swim suit, grandly stares out to sea while the woman pays him little attention.

Good Story shows an outdoor Veracruz res-taurant with three prominent *portales* where two crafty "sharpers" or salesmen are lingering over drinks after lunch. The alchohol has apparently taken effect. One man slurs what must be a lecherous joke to his glassy-eyed, crooked-mouthed colleague who may be too far gone to understand the punch line. Drinks are held unsteadily and the fragile, giddy state of affairs is echoed by the swaying backs of the bentwood chairs. The slight resort to physiognomy—the exaggerated noses, mouths, eyes, jaws, and fingernails—and the swaying furniture creates a tipsy ambiance that is decidedly comic.

In *Three Cats*, a trio of overdressed, lavishly made-up women pause between a moment of gossip to survey the unseen potential male clientele in a Mexico City nightclub. They barely even pretend to be interested in one another, as they wait for whatever wealthy *señor* who might happen on the scene. In this simple glimpse across the sharply lit table, Durieux delineates the less than wholesome character of these "cats" of the night. In *Boredom*, Durieux unmasks one pervasive social pattern of the Latin American bourgeoisie: the confinement of the women to the house during the evening hours while their husbands seek entertainment elsewhere, a situation the artist observed many times, especially during her lengthy stay in Cuba during the 1920s.

Nothing symbolized the upward-bound aims of the Mexican middle class more than fancy clothing. Under strain in the shifting stratification of this newly developing country, busi-

nessmen, professional men, and their wives were expected to obtain goods to advertise their new rank in society. Suits, dresses, and hats were less burdensome to the pocketbook than a car or an hacienda and were readily available due to low-wage labor created by the influx of peasants into Mexico City after the 1919 Revolution. As Durieux remarked: "These Mexican women would accumulate as many clothes as their husbands would give them money for."[4] In *Dressmaking* we confront this earth-shaking, Daumier-like creature, who commands the fitting of a new evening gown as the two petite seamstresses labor manfully at this herculean job while material cascades down the mighty slopes of the client's body. One of Durieux's clever stratagems as a satirist is to coax the observer to imagine the next situation her victim will face; and our mind spins when we picture the scene of this bourgeoise *Gargantua* making her grand entrance in the low-cut gown at some Mexico City nightspot. It would be almost as ludicrous as the burlesque dancers in *Teatro Lirico* (figure 9), which reveals the Mexican penchant for plump women. The artist cleverly bears in on the rolling thighs, breasts, and cheeks of this chorus line of strippers who fashion themselves to be seductive to the nearly all-male audience (only North American women and female Mexican intellectuals dared to enter one of these burlesque houses).

Not all of the foolish behavior of Mexico City could be claimed by the indigenous middle class. As part of the sizable American colony living in Latin America, Caroline Durieux had many occasions to see and expose the foibles of those representatives from Standard Oil, Goodyear Rubber, and International Telephone and Telegraph who were trying to manage far from their homes in Pennsylvania, Indiana, and Georgia. This was the offbeat side of the Mexican scene, not explored by the Mexican artists themselves. Rivera and Siquieros were too busy cataloging the atrocities of the Spanish colonialists to attend to the follies of yankees in Mexico. No one can call Durieux's Mexican prints political in intent, but inadvertently, she did expose the soft underbelly of the Mexican Revolution—that independent Mexico was still tied to foreign capital and its officials who led comfortable lives in their midst and provided dubious models for the aspiring Mexican bourgeoisie. Caroline and Pierre Durieux kept at arm's length from the American colony, only partaking in the country club functions when absolutely necessary. Polite and subtle as always, Durieux was, nonetheless, a cynical commentator of the gringo behavior.

One devastating example of this is seen in *Golfer* (figure 10), where it becomes clear that the American middle-class man was also concerned with cutting an imposing figure of style. *Golfer* is a vignette of the Mexico City Country Club, where Caroline occasionally visited to watch Pierre play a round of golf. This gringo golfer (who is not Pierre, incidentally) seems

4. *Ibid.*

12

less concerned with a low score than with high marks as a fashion plate. From foot to head, the George Raft shoes, diamond-patterned socks, plus fours, billowing shirt, brush moustache, and lacquered hair, become a sharply lit absurdity against the stylized, grainy golf course. We are led to conclude that this sportsman is more likely to blow away like a glider in the next strong wind than to reach the green with his five-iron. In the best satirical tradition of Daumier and Toulouse-Lautrec, Durieux relies on incongruity for comic relief: people believing they are something that everyone else knows they are not; or people getting into ridiculous situations they cannot escape, or may be only slightly aware of, but for which they only have themselves to blame.

It was on the dance floor that the North Americans (which is what people from the United States were called to distinguish them from other Americans who lived south of the border) seemed particularly vulnerable to Durieux's ice-cold eye. No situation more consistently appealed to her than people dancing or people watching others dance. "Dancing offers strange individual movements, and many chances for preposterous, uncomfortable situations found in few other activities." *Teatro Lirico* proved this statement. Another example is *Bipeds Dancing* (figure 11), where North American businessmen and their wives are shown swaying, grappling, lurching—one woman even winces with pain from her partner's misstep—on the dance floor. The couple in *Dancing With Vigor* (figure 12) is more animated but no less absurd than the

Bipeds Dancing. This slick, tuxedoed dandy with waxed moustache and hair moves his partner so swiftly that her hair stiffens from the motion. Durieux places the principal figures close to the picture plane, blots out details of the dance floor through a searing light and works with a succession of rounded arcs—the bracelets, glass ball lights, human ears, and the dominant loop of the man's arm—to accentuate the dizzy motion of the dance. In all of these Mexican Series prints, Durieux places herself in the long satirical tradition of making frequent use of peculiarities in costume as indexes of character. Facial expressions are understated. Anger, hate, lust, greed—the more dramatic passions—are seldom mirrored on the faces of Durieux's figures. But surprise, indifference, arrogance, bewilderment, slight vanity, and every known quiet expression are present in the common faces (and body postures) of the figures that people her satire.

The North Americans seem nonchalant to their silly appearance in *Fish* (figure 13), but they are downright arrogant and boorish in *Preview*, *Nice Men*, and *Rugged Americans*. These four prints were executed in Taxco in 1936 and were highly generalized types based on the artist's recollections of North Americans seen both in Mexico and the United States. The hovering figure in the modern art gallery in *Preview* (figure 14) disturbingly impinges on the viewer's space, and this print draws on the age-old tradition of the satirist mocking those aesthetes or connoisseurs-come-lately who presume to be knowledgeable about art. The jaded sophisti-

cates of *Nice Men* (figure 15), *Nice Women* (figure 16), and *Rugged Americans* (figure 17) represent a strain of the gringo upper middle class that has few of the innocent, ingratiating idiosyncracies of the Mexican bourgeoisie.

Durieux's Mexican Series prints were straightforward in technique. The pictures of bathers, dressmakers, priests, and burlesque dancers played basically on bold contrasts of black and white. She deployed little of the free-flowing, interrupted, darting lines favored by Sloan, Bellows, Robinson, and other leading lithographers who were schooled in newspaper graphic work rather than in academies. Working deliberately, Durieux converted her rough sketches into broad but tightly controlled masses and kept her forms within a closed boundary. While she did not dwell on fussy details, she refused to sacrifice strict clarity of form, demonstrating again her link to the nineteenth-century life-drawing tradition. Bending over the grained stone, Durieux quickly learned the feel of its surface, its potential for blunt form or many varieties of tone. She discovered how to manipulate a blunt crayon for the darker tones and a thinner and sharper one for the lighter. She preferred closely valued tonal modulations to the dramatic chiaroscuro of Daumier's urgent political lithographs. Slowly, she built up hatched tones which conveyed the lighthearted ambiance that characterizes *Acapulco, Bipeds Dancing, Good Story*, and most of the other prints of the Mexican Series. Her immediate affection for lithography meant that she would do little painting after 1930, and yet she exploited a wide range of greys in her prints that suggested color. Her compositions were usually hierarchic: one of several major darkened figures (with spot-lit faces) establish mastery over smaller and lighter figures and accessories. This central, tableau arrangement is evident in *Golfer, Dancing with Vigor, Acapulco, Good Story, Dressmaking*, and *Priests*.

The North American Series featured an almost total stripping away of background and setting. Narrative qualities that empower the Mexican Series prints are frozen out by the stark, blazing white light that freezes the repressed figures of *Preview, Nice Men*, and *Rugged Americans*. Technical considerations played a part in this shift to a more astringent style. At the urging of the printer, George Miller, Durieux experimented in the North American Series with zinc plates that were ground to simulate stone: zinc did not afford the artist opportunity for full three-dimensional effects, and Miller cautioned her to "work linear." [5] Even so, the wire-thin drawings of this series indicate that she went beyond the dictates of the medium, and was motivated by the caustic North American subjects. Just as the solid, full-bodied drawing suited the thick physiques and robust earthy satire of the Mexican subjects, so the razor-edged drawing style perfectly represented the pseudosophisticated character of the North Americans.

5. *Ibid.*

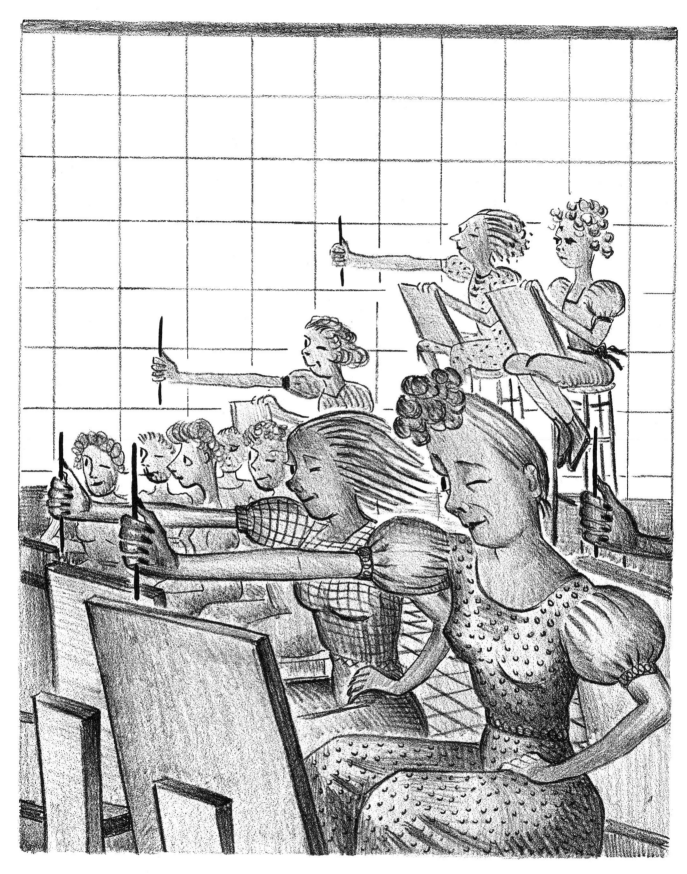

1 *Art Class*

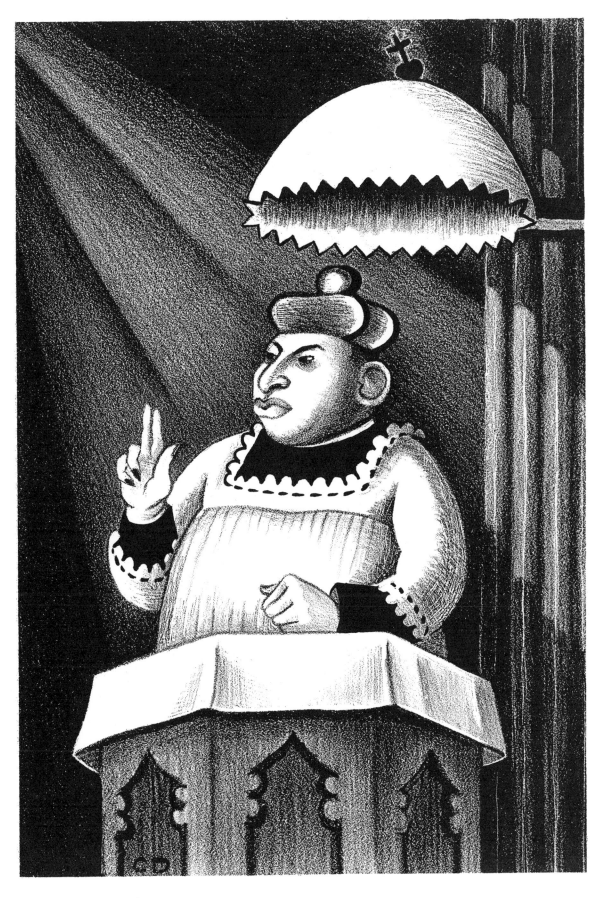

2 *Benediction*

3 *Priests*

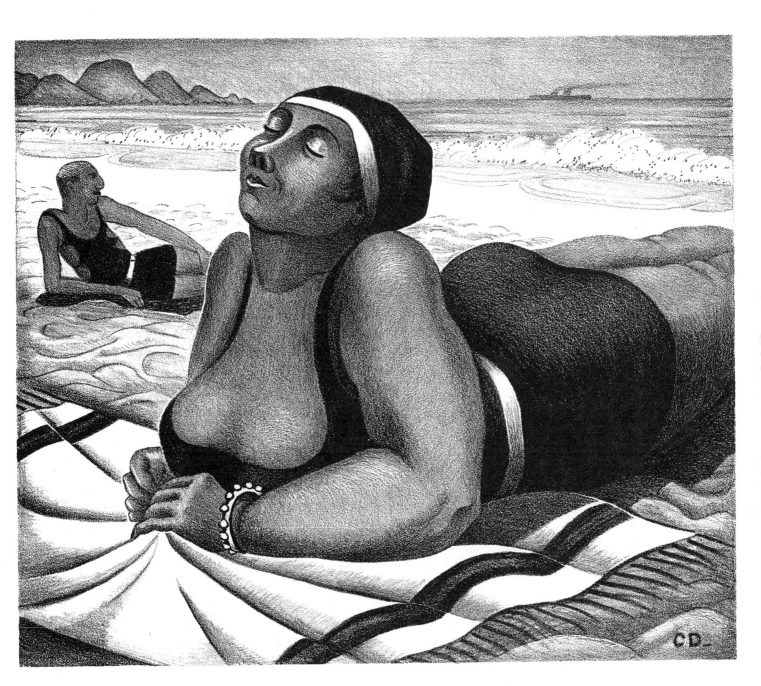

4 *Acapulco*

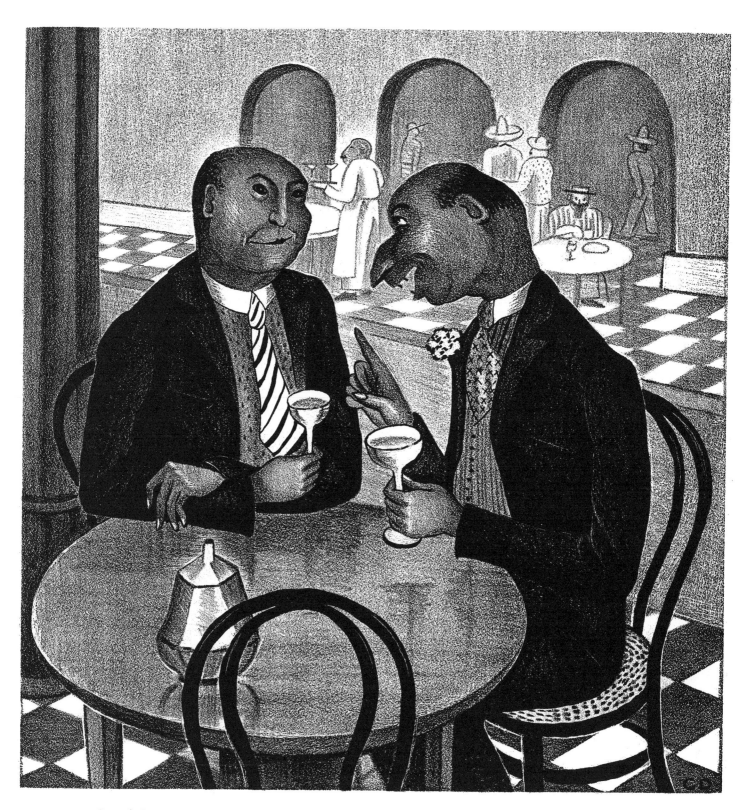

5 *Good Story*

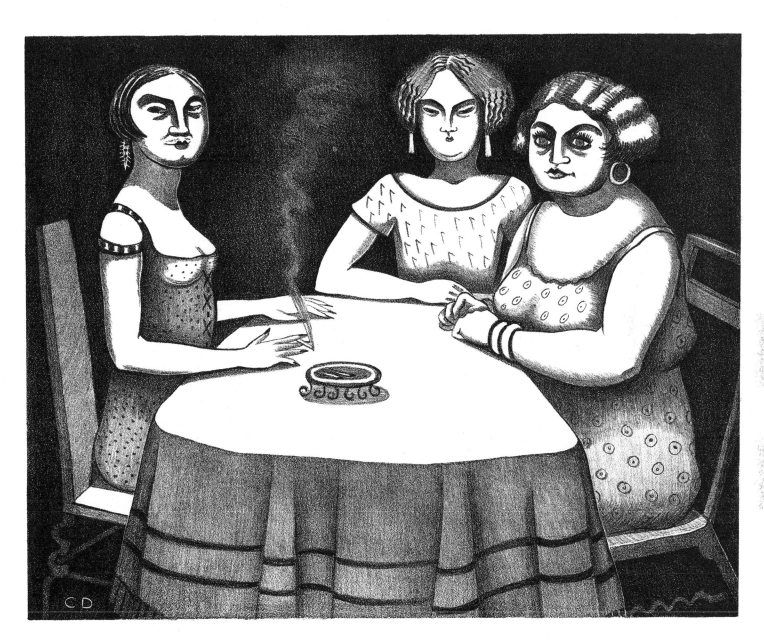

6 *Three Cats*

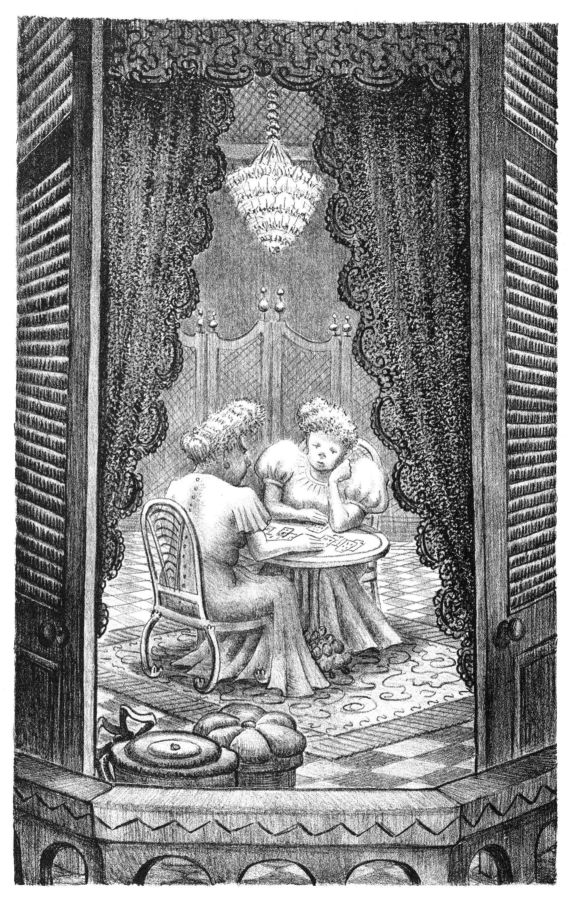

7 *Boredom*

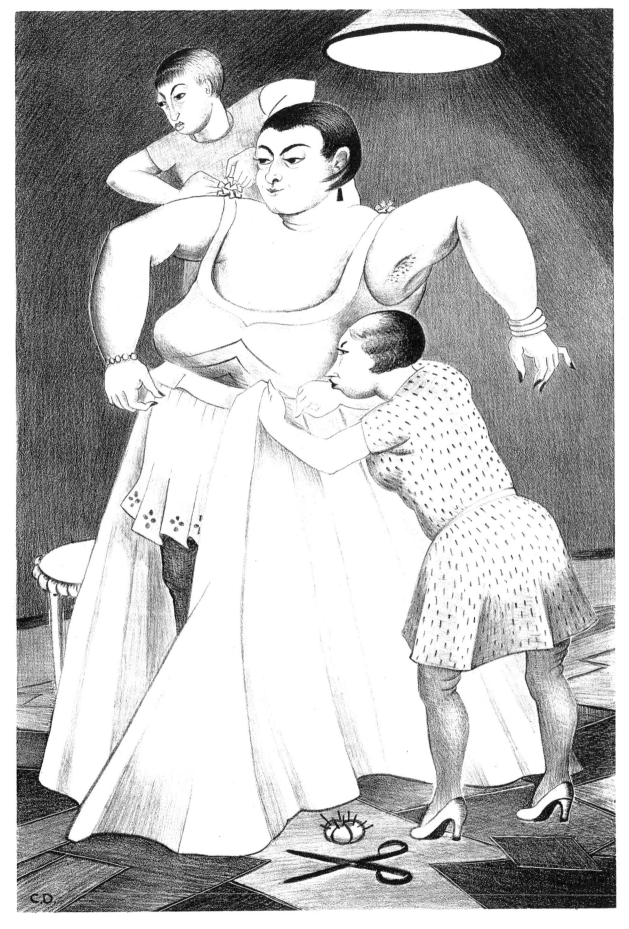

8 *Dressmaking*

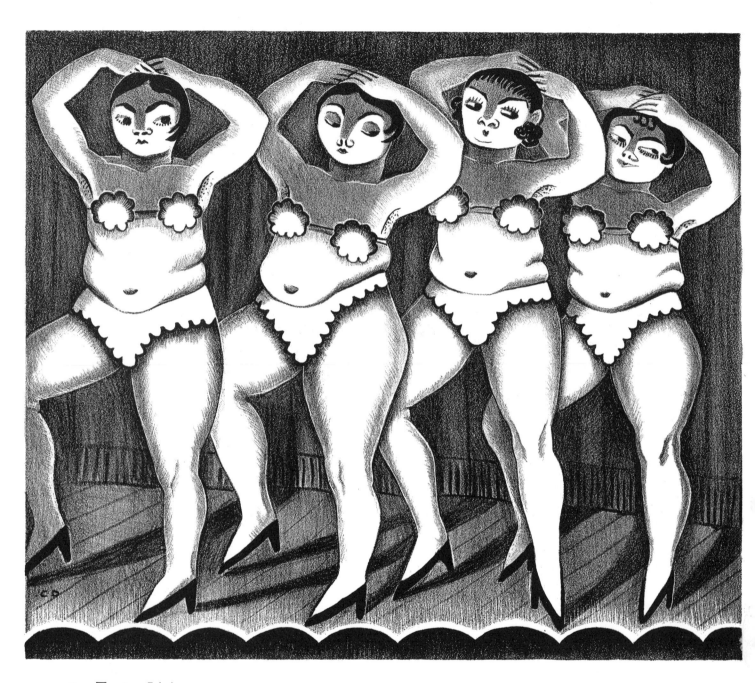

9 *Teatro Lirico*

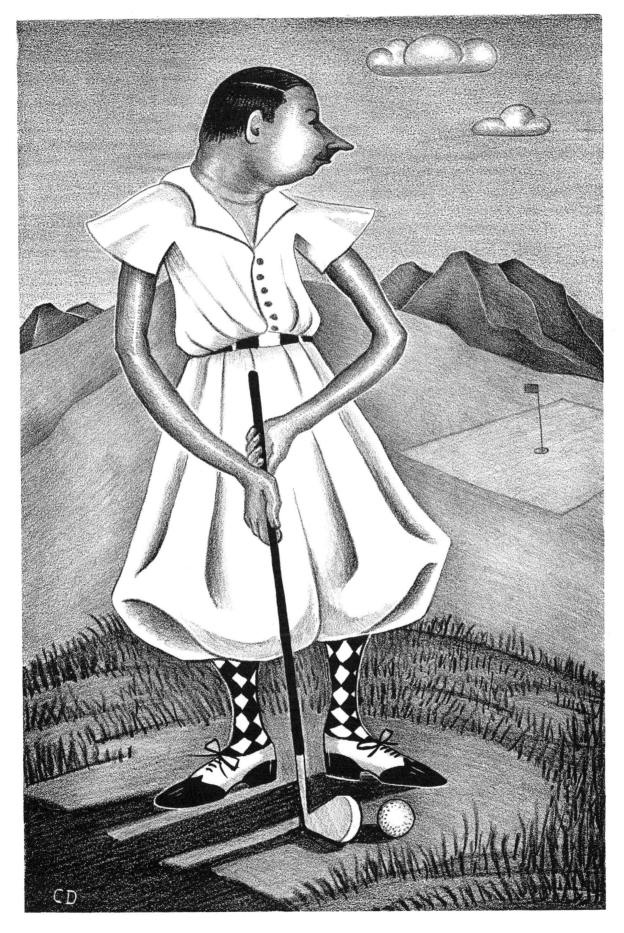

10 *Golfer*

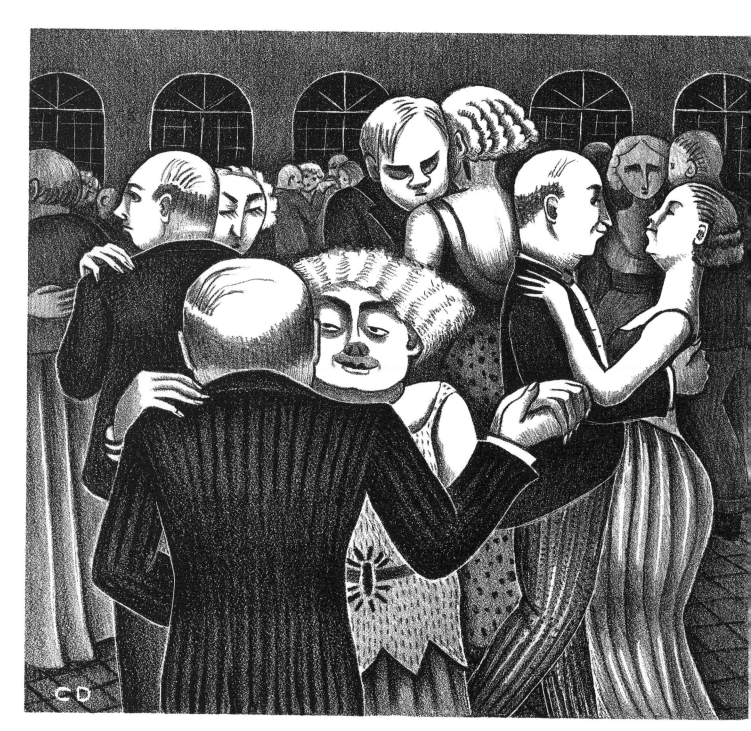

11 *Bipeds Dancing*

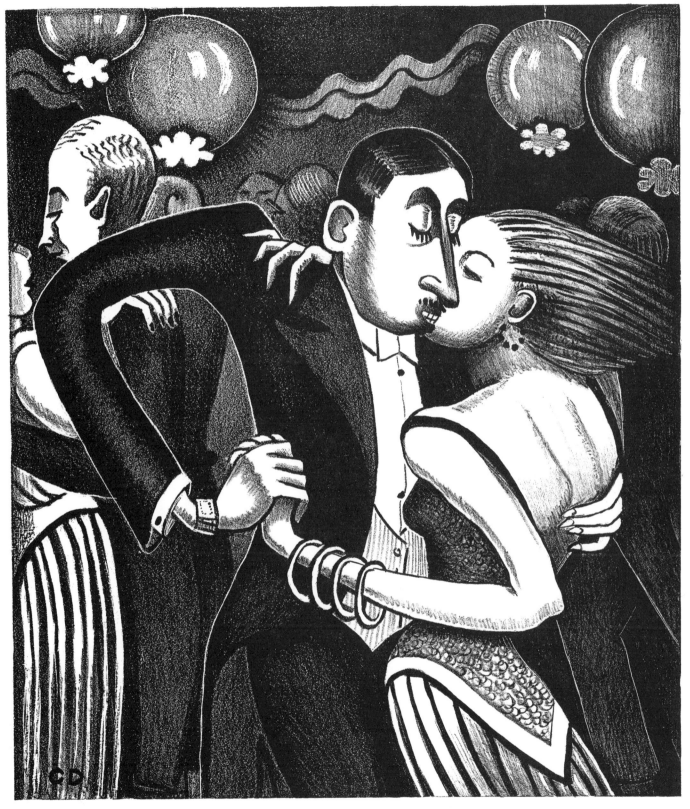

12 *Dancing with Vigor*

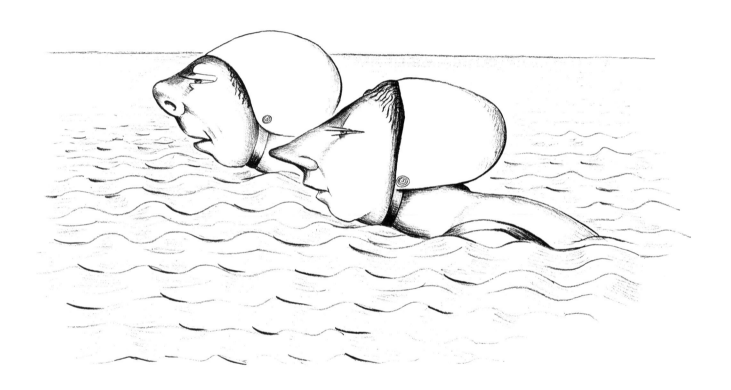

13 *Fish*

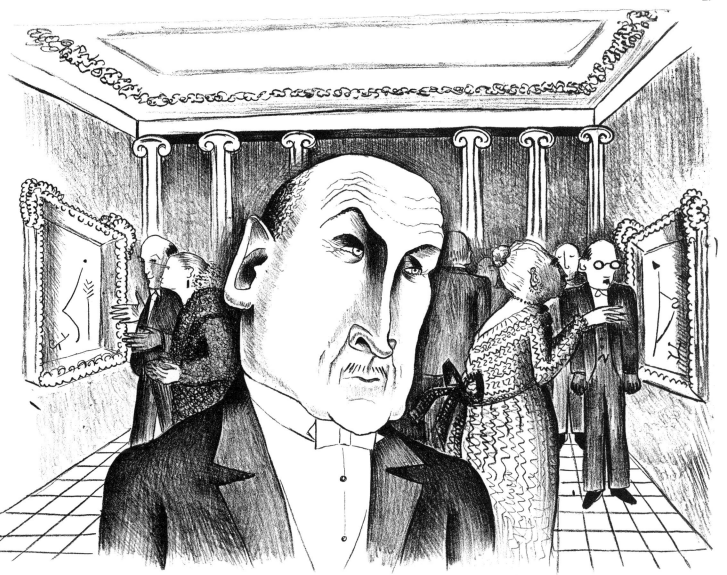

14 *Preview*

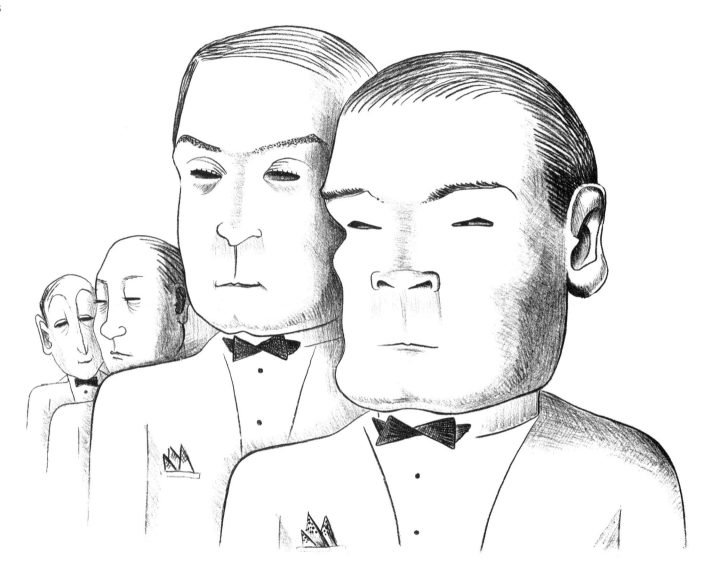

15 *Nice Men*

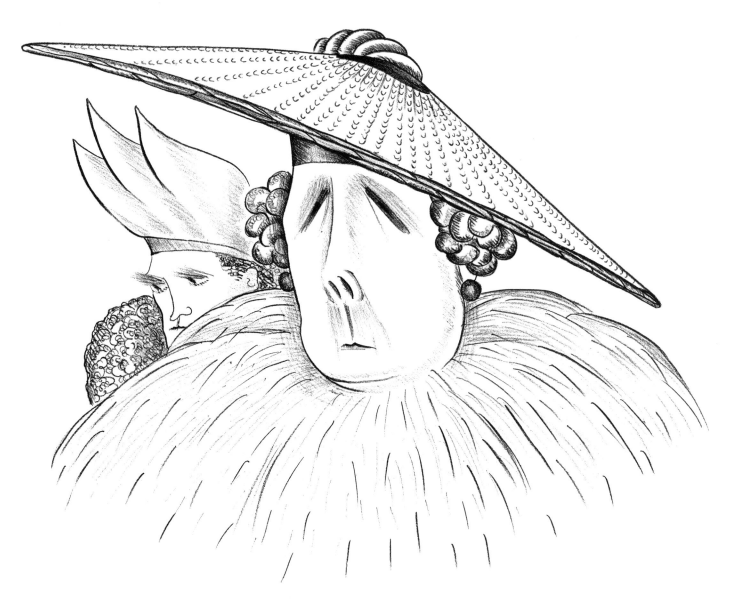

16 *Nice Women*

17 *Rugged Americans*

18 *Playboys*

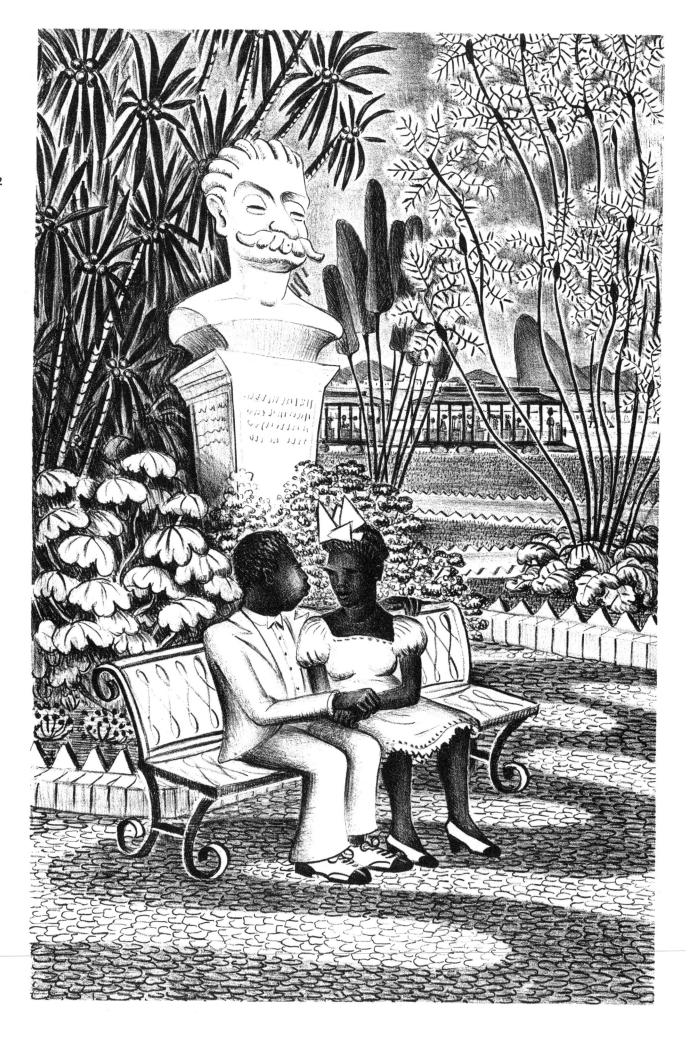

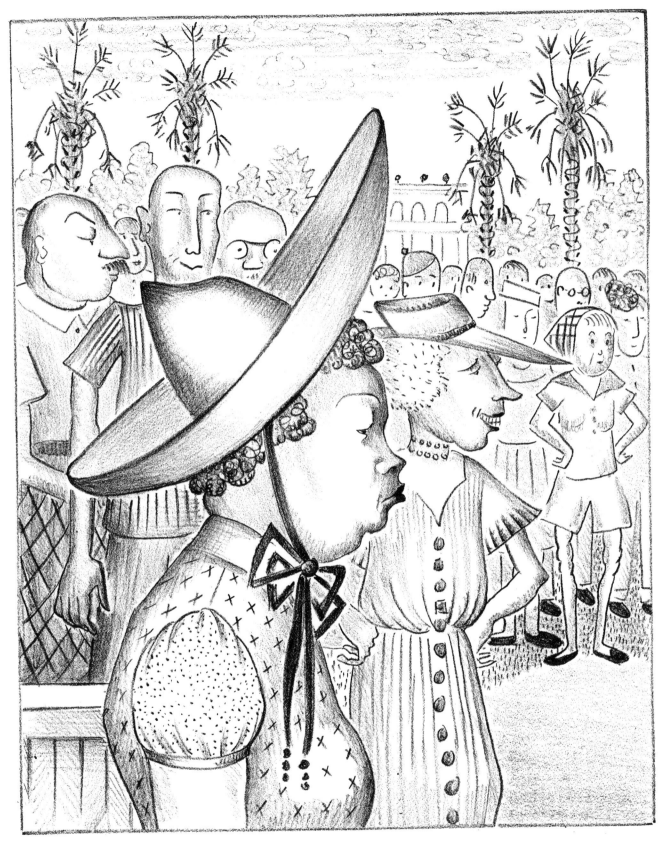

20 *Spectators*

19 *Park in Rio*

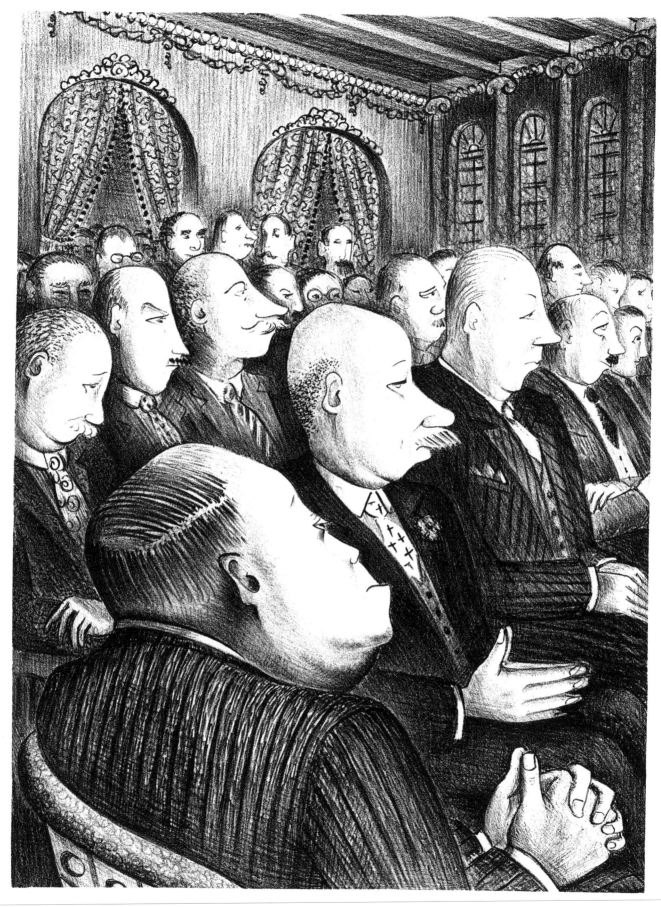

21 *Los Diplomaticos*

II

New Orleans

Caroline Durieux's prints of the 1937–1942 decade are roadmaps for the complicated landscape of Creole society and for other aspects of New Orleans. A serious illness forced Pierre to return to Louisiana near the close of 1936, and he and Caroline took an apartment on Chârtres Street, prowling old familiar haunts of the Vieux Carré and reacquainting themselves with the behavior of different professions and races in the Quarter. Some of these prints are nostalgic, partly reminiscences of Caroline's youth; others resulted from fresh observances of the French Quarter in the 1930s. The satire of nuns and blacks was affirmative, buoyantly cynical. Durieux's lithographs stayed on the periphery of the raging issues that divided artists during the thirties. Whether art should celebrate or criticize familiar American institutions and ways, or move away altogether into a formal abstract language, were questions and issues that applied only indirectly to her art. Abstract, nonrepresentational art did not interest her at this time, although she would occasionally turn to it in her color clichés-verres of the 1960s. Radical politics were in the air during the thirties, and artists were catching it left and right. Caroline's social conscience was stirred by the misery of the Depression and the growing menace of fascism, and she gave testimony to her concern in one memorable lithograph, *The Beggar* (figure 22), which was reproduced in the socialist journal, *The New Masses*. She constantly talked politics with reform-minded friends and assumed command of the Louisiana division of the Federal Art

Project of the WPA, a government-sponsored art program established by Franklin Roosevelt that was usually administered locally by liberal artists who were sympathetic to the aims of the New Deal. But Durieux never wandered into the wasteland of political ideology in her art. No scenes of breadlines, lynch mobs, mine disasters, labor strikes, and police raids, appeared in her prints as they did in many American printmakers of this age. Propaganda art was not her style; art that pleaded a social cause ran counter to her "Creole individual streak." She preferred to needle, not bludgeon, the enemy, which she continued to identify as human self-delusion rather than specific politicians or institutions.

At the same time she kept some distance from the southern regionalist artists and writers who were holding up southern culture as a noble antidote to the evils of modern industrial life, the Depression being just the latest and most fearsome manifestation of the machine age. Durieux felt proud of her Louisiana heritage, and her prints do have a distinct local flavor, but she was really more interested in using New Orleans subjects to comment about the general human condition than to simply record and honor local lore. Moss-draped trees, pirogues on the bayou, and Huey Long she scrupulously avoided in her satire. She also held no illusions that southern men and women, especially those she watched in New Orleans, were the innocents that the regionalist writers and artists made them out to be. She sensed that southerners were as material-minded and status-conscious as people she had observed in New York and Mexico City, and she felt no patriotic duty to overlook these flaws in her native culture.

It takes an uncompromising skeptic like Durieux (or Edgar Degas) to resist the lure of live oaks, Spanish moss, Greek Revival mansions, darkies in the fields and other Louisiana antebellum lore. Louisiana is the land of moonlight and magnolias as hundreds of hack artists never cease trying to remind us. Durieux's one excursion into Mississippi River folklore was *Plantation Garden*, 1946 (figure 23), which belies its picturesque title with its uncloying realism. It reveals Miss Bowman, last of the original family that owned Rosedown Plantation, standing in the garden "looking as old as the oaks." She represents a final symbol of the passion of an old way of life (in 1942, Rosedown had not yet been restored by Houston millionaires). "It struck me that the old gnarled woman, the century-old trees, and the late afternoon light all went together as a theme,"[1] states the artist.

In New Orleans, she became art instructor at her alma mater, Newcomb College, which soon inspired some quiet impeachments of the hallowed groves of academia. Durieux was no more impressed with affectations of learning than with the status aspirations of the Mexican and North American bourgeoisie. The cap and gown seen so prominently in *Commencement*

1. Interview, Caroline Durieux, April 30, 1977. See also Caroline Durieux, "An Inquiry into the Nature of Satire" (M.A. thesis, Louisiana State University, 1949), 19.

(figure 24), *Academic Portrait* (figure 25), and *Founders Day* (figure 26) were nothing more than the intellectual's badges of pretense—notes of selfdelusion just as surely as the plus fours and bulging evening gowns designated the petty material strivings of the Mexican middle class. The self-conscious dignity, the unsmiling dedication to higher ideas, the windy lectures that droned on, and the general puffed-up sense of self-importance were all pilloried through the academic uniform that has always bunched at the knee, pinched at the neck, and perched precariously on the heads of the faculty and graduates.

Durieux occasionally took a side glance at the Catholic Church. All her relatives in New Orleans were devout Catholics, and as a youngster she attended mass at St. Louis Cathedral with her father. But her mother, who had been raised in New York, was an Episcopalian, and she instructed Caroline in the Protestant doctrines. Charles Wogan was a "tolerant Catholic" who used to tell his children that "one religion was as good as the next. It was all the same one God." [2] Invariably, Charles and Caroline would arrive late to the cathedral just in time for the raising of the host and the swinging of the incense: it was the visual spectacle of the mass that appealed to father and daughter, and often they ducked out of St. Louis Cathedral before the end of the service. It is not surprising that Caroline did not take the Church anymore seriously than other entrenched institutions. As far as her satire was concerned, nothing was forbidden fruit, even

the Church functionaries, although she directed no malice their way, as her early Mexican prints, *Benediction* and *Priests* reveal. A variation of the latter is seen in one of the most widely reproduced Durieux lithographs, *In the French Quarter—New Orleans*, or *Nuns Walking* (figure 27), where she pictures two nuns walking through the Vieux Carré. The pious, studied dignity of the nuns seems at odds with their unmanageable habits. These brides of Christ are trying (not altogether successfully) to keep from being distracted by the hedonistic atmosphere of the French Quarter, and to ignore one aspect of machine-age progress, the sewer grating, which is introduced to contrast with the "ridiculous survival from the medieval age," the nuns' garments. [3] Again, incongruity of personality and setting is exploited for good comic measure with the final effect being one of good-natured mockery, not bitter denunciation that characterized the anticlerical prints of Adolf Dehn and George Grosz.

The Negroes of New Orleans also received a sympathetic treatment from Durieux. Her lithographs of the black community avoided the stereotypes, condescension, and false exotica so often seen in paintings and prints of the 1930s. Growing up at the edge of the French Quarter, Durieux lived in close proximity to the neighborhoods of black people, although she only knew them personally as servants. The rigid segregation system prohibited any contact be-

2. Interview, Caroline Durieux, April 30, 1977.
3. *Ibid.*

tween the races at the public schools, Newcomb College, or in elite social circles. She made a series of drawings for the WPA in 1937 that spoofed the raucous Baptist services, voodoo queens, "sportin' ladies," and funeral practices of New Orleans Negroes, but other drawings and lithographs were more restrained accounts of this subculture that she came to know much better during her years as head of the WPA project in Louisiana. *First Communion* (figure 28) depicts a young girl who appeared to the artist as a "trapped, frightened doe, her pretty black face peering through the white veil in a way I found both touching and artistically pleasing." This "child of nature is looking at us in startled surprise from behind the symbolic bars of a first communion veil."[4] The girl was just one of many Negro Catholics Durieux saw and talked to near her Chârtres Street home, for most of the Vieux Carré Negroes were Catholic unlike those uptown who were mostly Protestant.

The artist was more satiric in *Bourbon Street* (figure 29), done at the request of Carl Zigrosser for his wartime Artists for Victory exhibit in New York. Deciding against a fighting-action scene, Durieux recorded this exuberant night-club scene of mulatto jazz singers belting out a tune to the appreciative servicemen's audience. The successive puffs of flowers, earrings, hair curls, and lamp balls set a linear tempo that parallels the syncopation of the Negro tune. Durieux's interest in jazz went back to the early years of this New Orleans music genre. Black jazz combos often played at the Tulane dances at-

tended by Durieux before and during World War I. "No white band could play the kind of music we wanted to dance to,"[5] she recalls. As for the French Acadians who emigrated to south Louisiana in the eighteenth century, Durieux has only once depicted a "Cajun" subject, probably because the Cajuns settled mostly in the Lafayette region and were not seen so frequently in New Orleans. *Taxidermy* (figure 30) shows a bemused Acadian woman, distinguished by her prominent feather hat which is almost a whole bird bearing close physical resemblance to the woman. These hats were in much vogue during the 1940s.

But, it was the Creoles, those New Orleans residents of French and Spanish descent, that especially intrigued Caroline Durieux. Her watchful eye caught these men and women in many different situations and impaled them in five or six unforgettable lithographs. Her own French ancestry made her admission into Creole society an automatic matter after she returned to New Orleans in 1936, but it was something like the royal family of Charles IV bringing Goya into the court—they did not seem to realize they had let the fox into the chicken coop. As Carl Zigrosser wrote in 1940, Caroline "saw beyond the inner Creole circle into the world at large."[6] Again, these prints were not usually portraits of identifiable friends; she took aim at a society, not a person.

4. Durieux, "An Inquiry into the Nature of Satire," 21.
5. Interview, Caroline Durieux, April 30, 1977.
6. Zigrosser, *The Artist in America*, 127.

40

Beauty Salon (figure 32) reveals a long, expansive row of women painfully primping for an opera, play, or perhaps a carnival ball. Like bugs caught on the end of the entomologist's pin, they find themselves captive—of their own obsession with glamour as well as of the hulking, hot machines. Durieux composes the picture around many small circular movements—the hoods of the dryers, the rugs on the floor, the fluting around the raised platform and the tubular furniture—to create a feeling of endless monotony. Daumier had used a similar device in *Ventre Legislatif*, suggesting the plodding corruption of the French Chamber of Deputies through the architecture of the chamber, "seen by Daumier as row upon expanding row, each dedicated to the fat and flabby in spirit as well as body." [7]

Hair and what one does to make it stylish was a recurrent satirical theme in Durieux's lithographs. Hair in various gradations of discomfort: hair that is pulled back, twisted, ratted, straightened, curled, rolled, piled high and forward into fantastic pompadours dominate the physical landscape of her women, the only competition for absurdity coming from the hats. From the cropped, mashed hair of *The Golfer* to the sculptured kinks of *Bourbon Street* to the bird's nest coiffures of *Boredom*, to the nettles of *Disirée*, to the anxiety-soaked strands of *Children*, the head of hair is one of the best barometers of human frailty and social aspirations. Durieux did not hesitate to embellish this feature for comic or tragic effect.

Irony is the stuff of satire, and the irony of *Reception* (figure 33) is unmistakable. Over the years, Durieux had suffered through her share of social club functions, listening to more catty conversations than she cared to remember, and lithographs like *Reception*, and *The Veil* (figure 34), were her revenge. *The Veil* is one of her most menacing domestic satires. The veil, of course, hides none of the viscious, parochial personality of this De Kooning-like clubwoman. There is no chance that the several inches of frilly silk material and the juvenile spit curls can soften this "sargeant major" as the artist characterizes her, whose every other feature has a Prussian effect. [8] Seldom did Durieux resort to grimaces in her satires, but the predatory teeth and muscles that tighten about the clubwoman's jaw make this perhaps her least subtle caricature.

In a lighter vein were *Dinner* (figure 35) and *Revelations* (figure 36). In the former, she jibes at the established New Orleans tradition of the small formal dinner party. The narrative was inspired by a specific dinner attended by the artist where an elaborate conversation developed concerning the illustrious ancestry of the monumental crystal and silver epergne that rises like Jack's beanstalk in the center of the table. So animated was the discussion of the epergne that "I began to feel as if the thing was

7. Frank and Dorothy Getlein, *The Bite of the Print: Satire and Irony in Woodcuts, Engravings, Etchings, and Lithographs* (London: H. Jenkins, 1964), 196.
8. Interview, Caroline Durieux, May 6, 1977.

growing right there before us," Durieux recalls. She took mental note of this absurdity, scratched a sketch out after the party, and turned it into this impish print later that year (1942). In *Revelations* the artist pillories women who have too much time on their hands and attempt to appease their boredom through gossip. Idle hands will unloose an indiscreet tongue. Here again the artist equates the furniture and human personality in this salon melodrama. The gossip is so shocking that the "chairs bend and writhe as if in their opinion, that which is being told would be better left unsaid . . . and the nap of the hooked rug on the floor stands on end."[9] The maiden aunt in the rear purses her lips in disapproval of the gossiping, but each woman in the forefront leans forward to embrace the other's tale of misdeeds. The caricature is minimal but effective.

In these many lithographs of the elite and those who would join the elite if given the chance, there is the bite of a social critic, as Diego Rivera and Carl Zigrosser pointed out many years ago. Durieux cannot, strictly speaking, be labeled a moralist. Unlike William Hogarth, she did not turn her satire into moral sermons denouncing the wayward lives of the bourgeoisie: her dancers, bathers, and gossipers do not go mad or die in debtors prison for their sins. Still they do wrong and their values are at odds with Durieux's own: thrift, work, modesty of dress, forthrightness, reason, secular humanitarianism.

By the 1940s Durieux's style had become simplified. Not so austere as the zinc lithographs of the North American Series, the stone prints of the New Orleans subjects were, nevertheless, more two-dimensional than the Mexican Series. Frequently in the New Orleans prints, the artist de-emphasized perspective, played up the contrasts of shapes and bare contours, and shied away from the intricate shading and chiaroscuro that suggested weight in some of the Mexican prints. Moreover, she rejected the involved narratives, subplots, and side thrusts at mythology, history, politics, and religion that characterized so much previous satire, especially that of the English caricaturists of the nineteenth century. Daumier, who would always remain as Durieux's guidepost, showed the way out of the labryinth of satirical tradition by reducing the complex interplay of themes to simple satirical effects generated by shape and relationship. Durieux's lithographs usually made one direct point per print. If her satire leans toward the extravagant on occasion, it is only because the uninhibited, exotic behavior of the city of New Orleans forced her hand.

Nowhere do the excesses of the New Orleans society manifest themselves more blatantly than at Mardi Gras, the last feast of the long revelry that precedes Lent each spring. Begun on a modest scale in the colonial years, carnival in New Orleans had mushroomed by Durieux's time into a unique American bacchanalia, highlighted by secret societies (krewes), masking

9. *Ibid.*; Durieux, "An Inquiry into the Nature of Satire," 11.

42

revelers, plays, balls, feasts, and lavish parades. When Durieux first became aware of Mardi Gras, the krewes were still dominated by the Anglo and Creole elites. However, by 1930 many other groups, political and ethnic, had worked their way into the Mardi Gras structure. In 1947 Durieux and two local artists, John McCrady and Ralph Wickiser, received a commission to publish a book of lithographs and drawings illustrating the highlights of Mardi Gras Day, or Fat Tuesday as it had come to be known.[10] Caroline's contributions were affectionate hymns to the celebration of Fat Tuesday, only partly satirical, with few undercurrents of social commentary.

Into *Rex, King of Carnival* (figure 40), she packs her composition with the rakish, pagan character who traditionally dominates Mardi Gras Day festivities. Heading a lengthy procession of floats and bands that sometimes stretch over a mile, Rex stops in front of the Boston Club on Canal Street and drinks a toast to the *Queen of Carnival* (figure 41), who waits on the balcony with her court of maids. When the Rex and other daytime parades break up, Comus, seen in *Night Parade* (figure 42), the first krewe organized to parade in 1857, takes over for a spectacular evening extravaganza. Black attendants carry torches to light the main float which carries the seated god Comus, who hovers above a mass of cumulus clouds. He grips the Cup of Mirth and Cheer and commands that these last hours of Fat Tuesday be "joyous and fantastic, for after Comus and midnight stretches another year of dull reality."[11]

Throughout the day, local citizens mask as coach dogs, pigs, clowns, and often as grotesques, such as seen in *The Death Masker* (figure 47). Masking was one of the first features of Mardi Gras and it has not always won full approval. When New Orleans was under Spanish domination, masking was discouraged for fear that the disguises would give "seditioners" a convenient opportunity to foment an uprising against the unpopular Spanish city government. Nonpolitical hoodlums used masking for their vandal purposes in the 1840s and 1850s, and some masks mocked the presence of carpetbaggers and scallywags during the Reconstruction era, much to the consternation of local federal officials. But in Durieux's youth, masking had once again become acceptable. As she remembers: "Mardi Gras was a day when you became someone else. Whatever you dressed up as, that became your character. You got outside yourself and it was a wonderful release."[12] This release she commemorates affectionately in *Coach Dogs* (figure 43), *Three Pigs* (figure 46), and *The Death Masker*. The latter was not meant to be morbid, but it does add a note of caution to the orgy and reminds us again that the artist is ever alert to good and evil, hope and despair —the dual nature of human existence.

Throughout the Mardi Gras season, the various societies hold costume balls, a long tradition summarized brilliantly in the droll 1942

10. Interview, Caroline Durieux, May 6, 1977; Ralph Wickiser, Caroline Durieux, John McCrady, *Mardi Gras Day* (New York: Henry Holt, 1948).
11. Wickiser, Durieux, McCrady, *Mardi Gras Day*, 64.
12. Interview, Caroline Durieux, May 6, 1977.

lithograph, *Carnival Ball* (figure 48), which was produced five years before publication of *Mardi Gras Day*. *Carnival Ball* has a sharper satirical edge than her later Mardi Gras prints. In Durieux's own words:

> *Carnival Ball* is a social ceremony with a serious objective. It is the one in which the mothers and grandmothers of marriageable young ladies present them to be appraised by their own social group. In the foreground, gossiping middle-aged women watch their debutante daughters (young replicas of themselves) parading in the Grand March. The men under mask who give this ball are used as decorative mechanical accessories in the composition of this picture. They are not the important people; it is rather the young girls in white, their mothers and grandmothers who are significant.
>
> In the background, dwarfed by the carpet-like expanse of their royal mantles, the king and queen look like toys for children to play with. On each side of the composition, forming two wings in the far plane of the picture, several rows of dowager chaperones complete the circular movement of the design and the satire of the picture as well. They obviously once looked like their daughters, the women in the foreground; and, by inference, they too were once debutantes like their parading granddaughters. These three generation of puppets repeat a seemingly endless social pattern.[13]

The Meeting of Comus and Rex (figure 49) at the Comus Ball depicts the climactic event of Fat Tuesday. After the band plays the refrain, "If ever I cease to love, if ever I cease to love," Comus and his queen, and Rex and his queen meet in the center of the ballroom and bow to one another amid the "muffled clapping of several thousand kid-gloved hands." [14] For some fifteen minutes Rex reigns over the Comus Ball.

Then, it is midnight and the ceremonies are over. The fast begins. In America there is nothing to compare to the extravaganza of Mardi Gras, and if anything, Durieux actually understated the theatrical pomp of carnival. With all the natural excesses, posturing, outrageous clothing, and in-built ironies of Fat Tuesday, the artist found no need to exaggerate Mardi Gras. Carnival was a caricature of itself, and just as Toulouse-Lautrec decided it was superfluous to caricature the already extreme acts of La Goulou, Yvette Guibert, Loie Fuller, and other performers of the Moulin Rouge, Durieux chose the sensible tactic of acting as a reporter of Mardi Gras, realizing that the inherent satire of the festivities would find their way into her lithographs.

13. Carl Zigrosser, Foreword, *Caroline Durieux* (Baton Rouge: Louisiana State University Press, 1949).
14. Wickiser, Durieux, McCrady, *Mardi Gras Day*, 68.

44

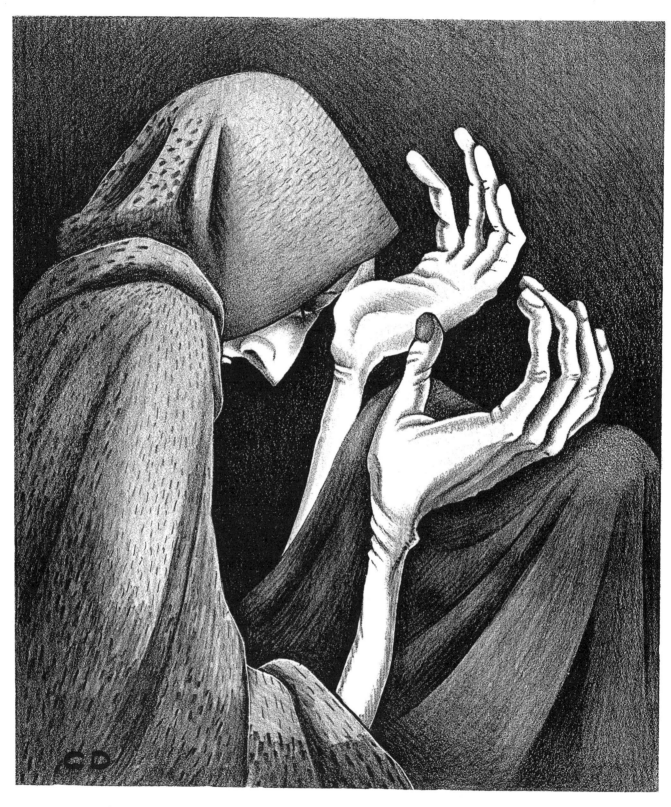

22 *The Beggar*

23 *Plantation Garden*

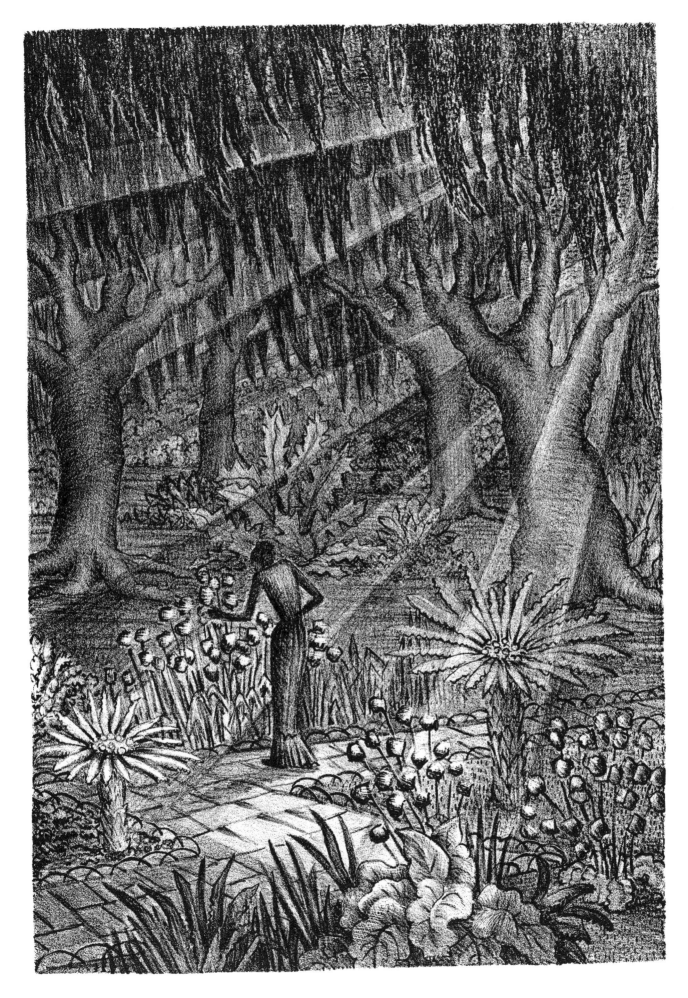

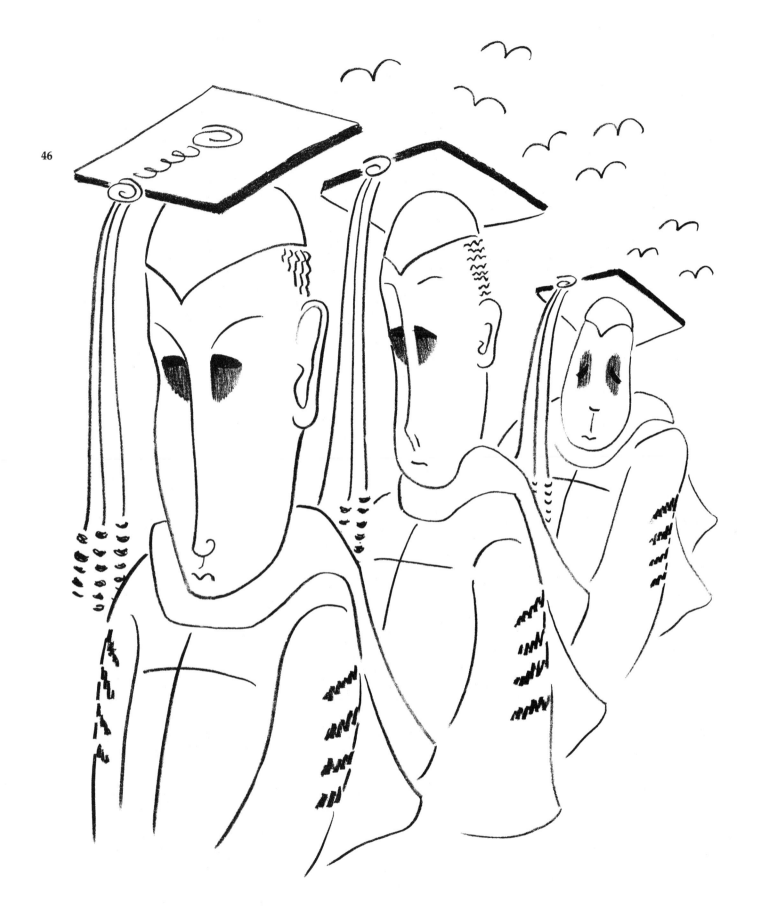

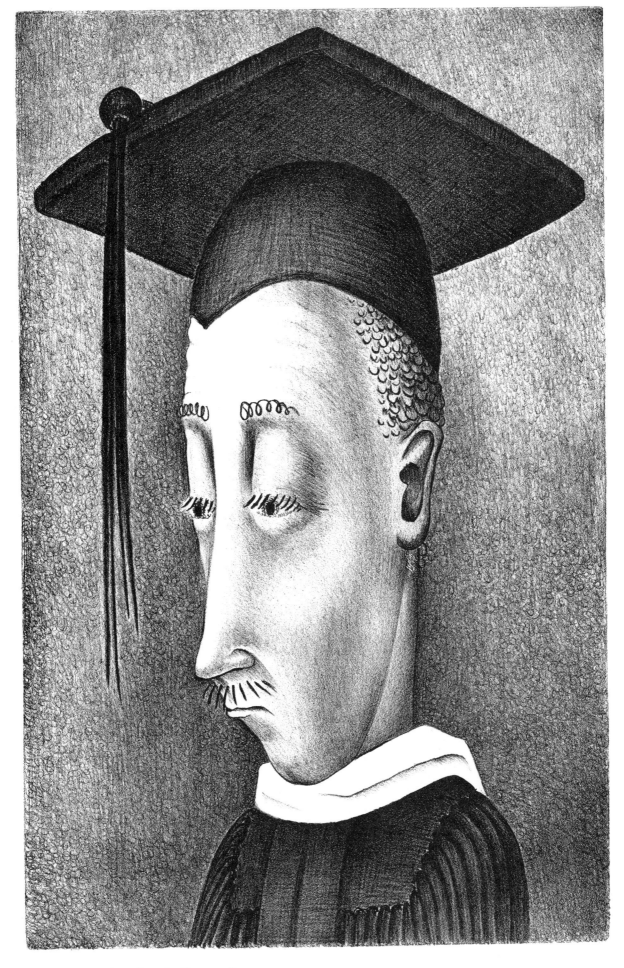

25 *Academic Portrait*

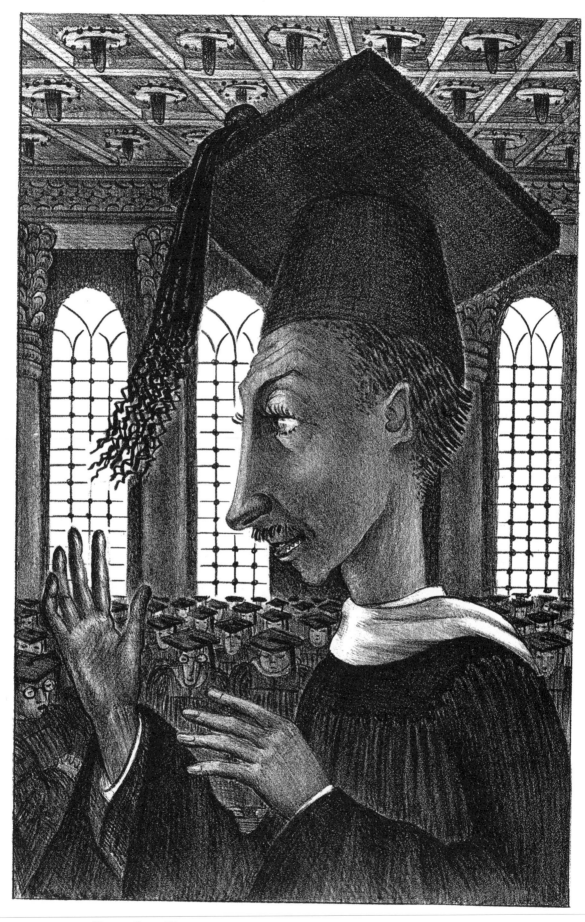

26 *Founders Day*

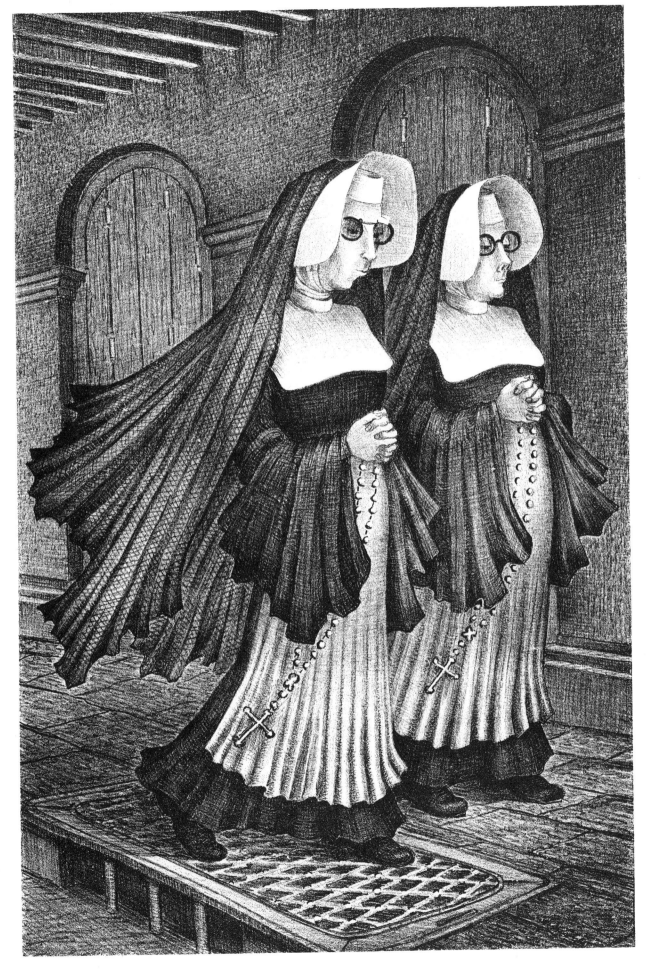

27 *Nuns Walking*

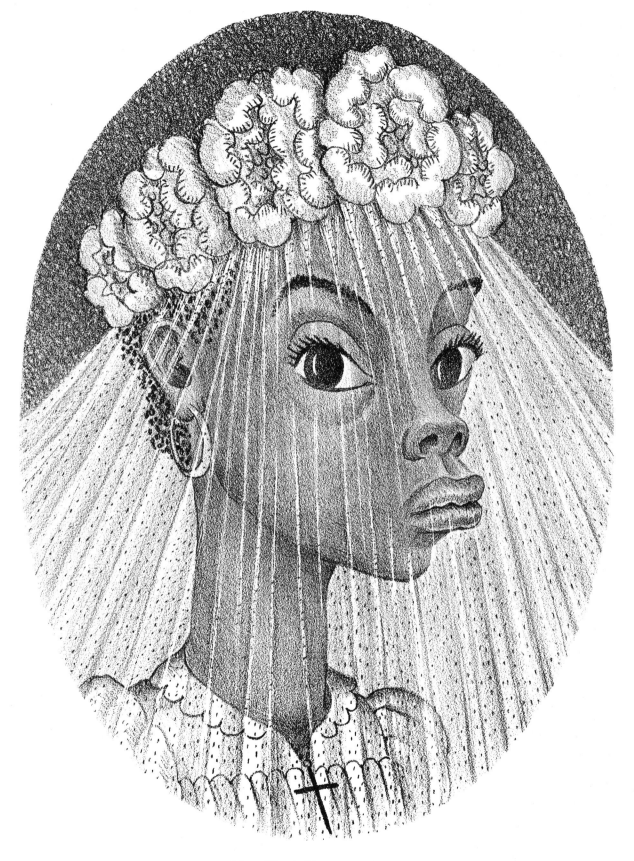

28 *First Communion*

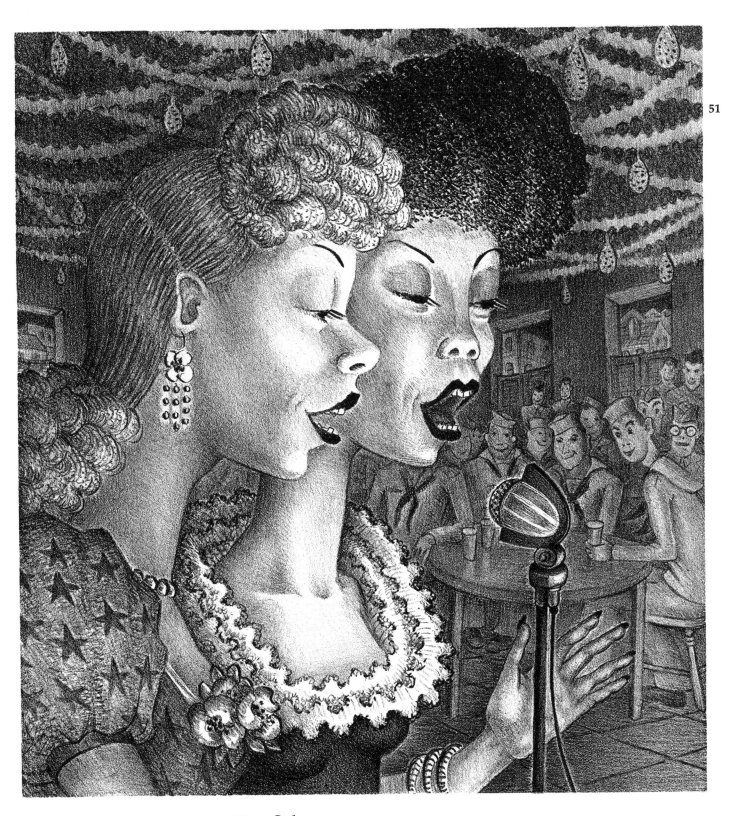

29 *Bourbon Street—New Orleans*

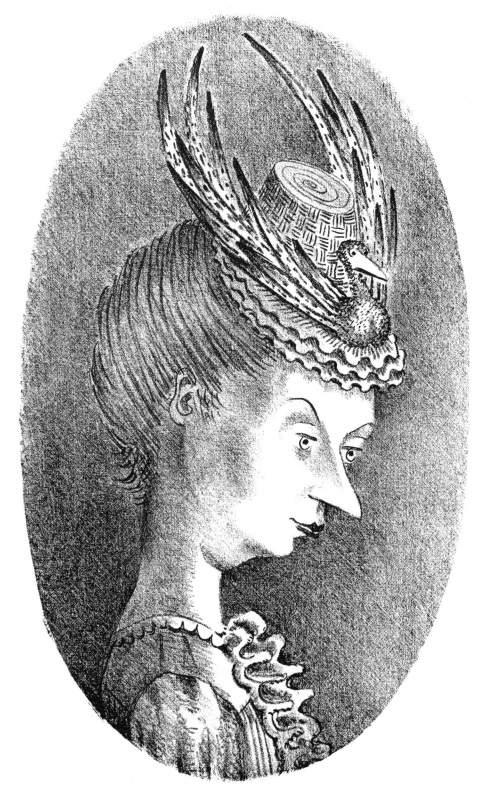

30 *Taxidermy*

31 *Loneliness*

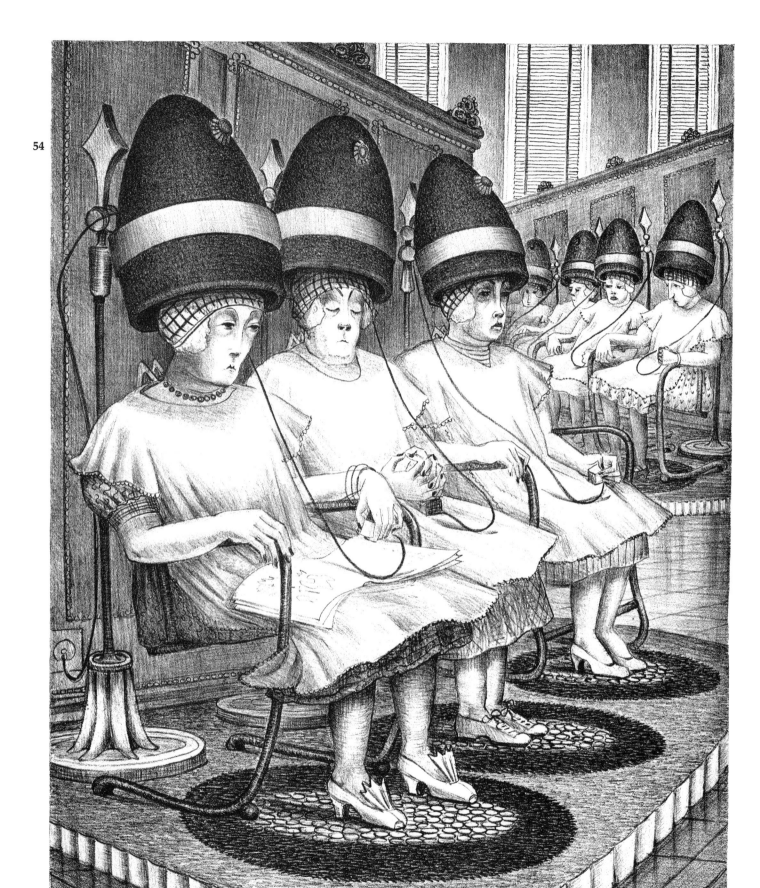

54

32 *Beauty Salon*

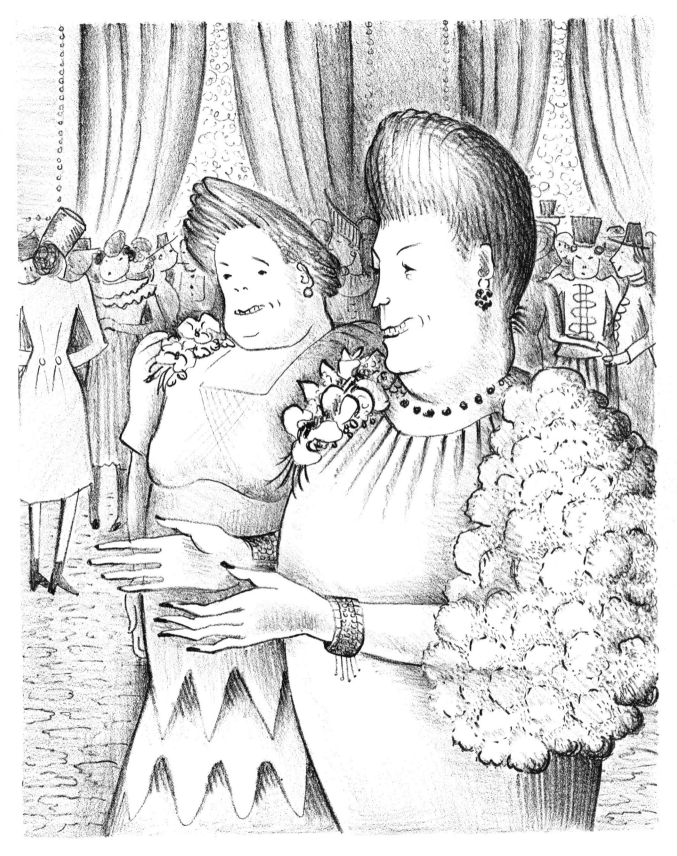

33 *Reception*

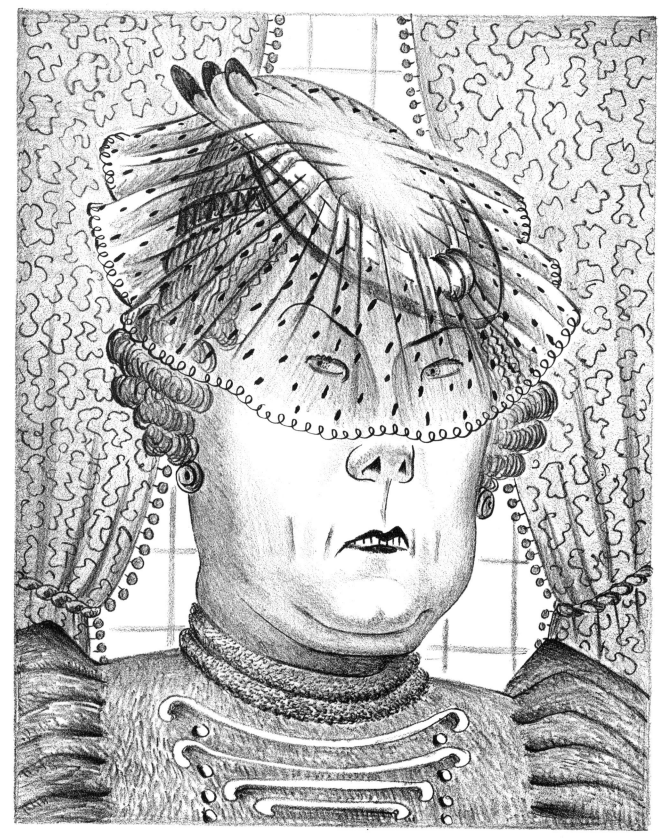

34 *The Veil*

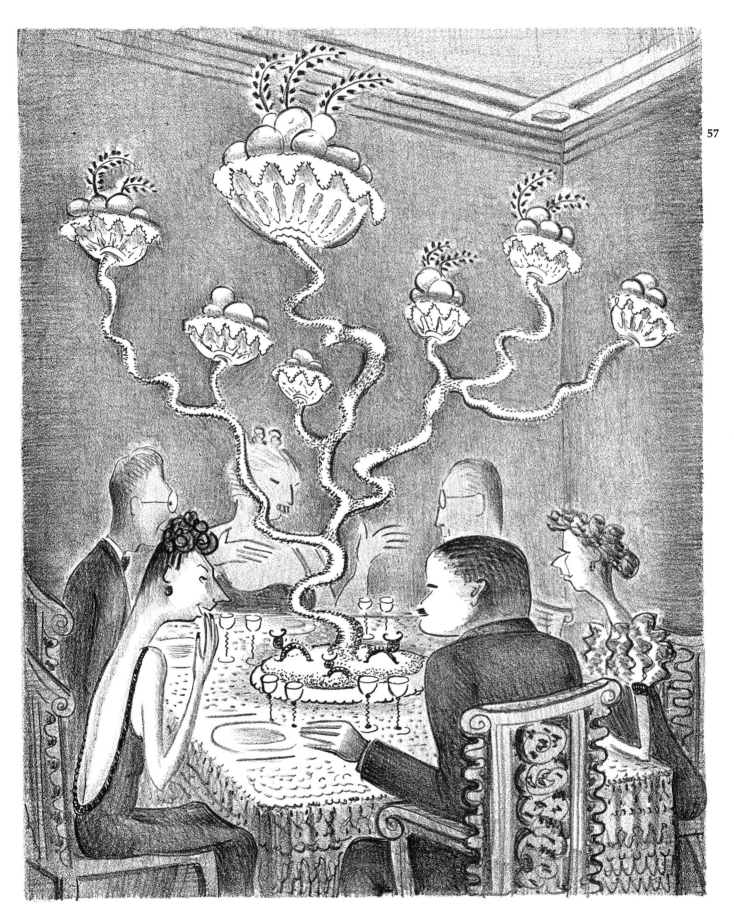

35 *Dinner*

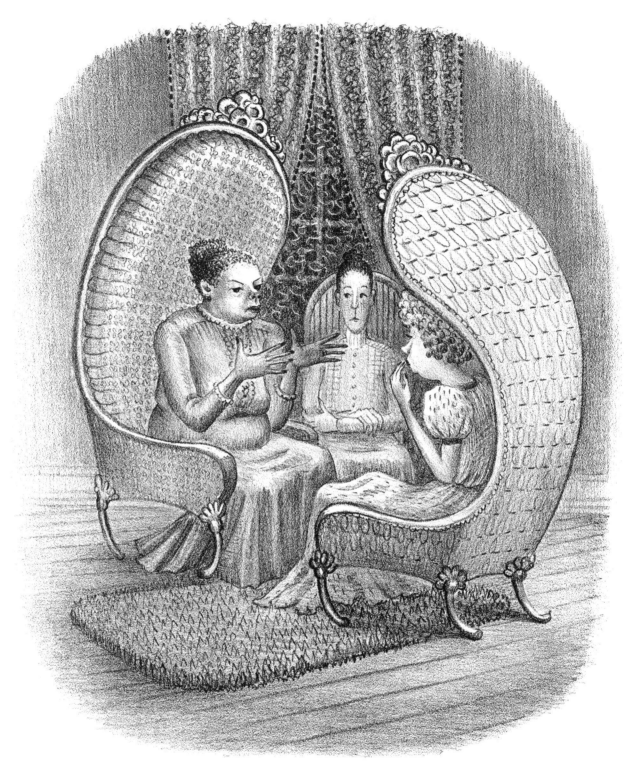

36 *Revelations*

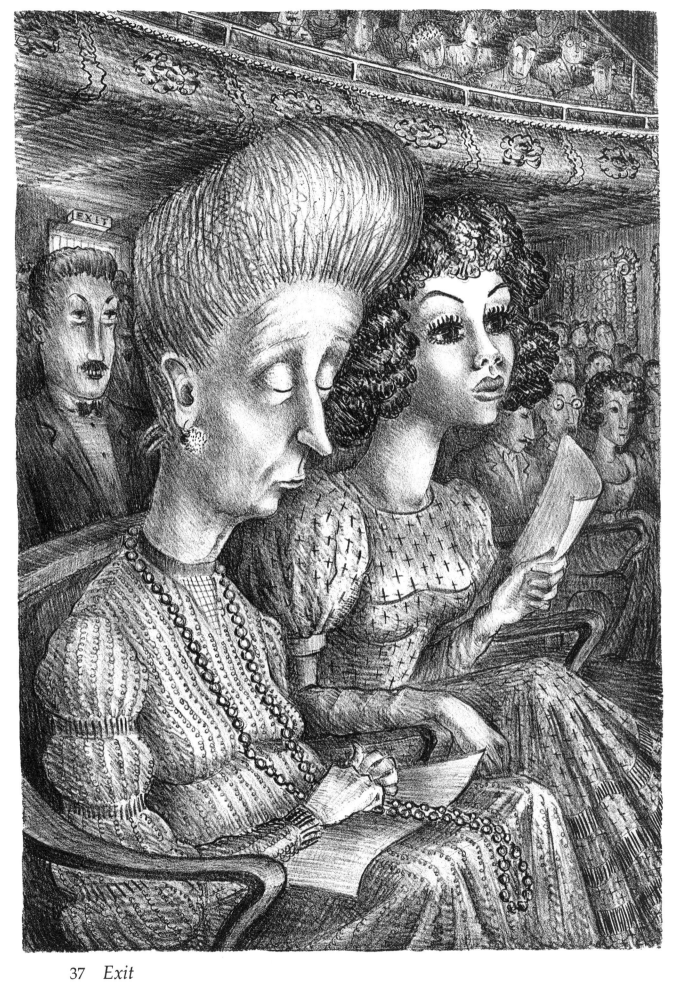

37 *Exit*

38 *Security*

39 *Opera*

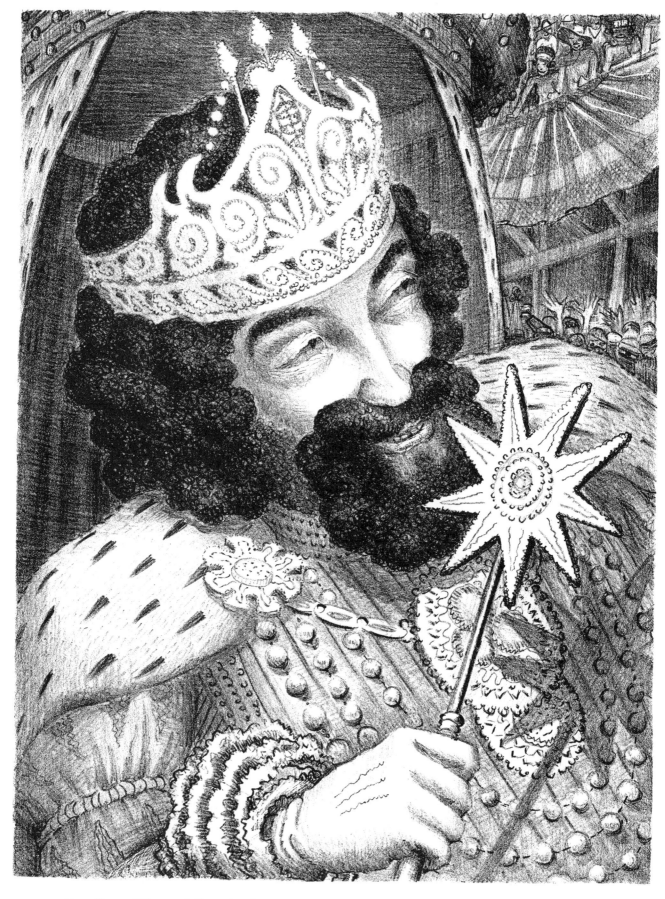

40 *Rex, King of Carnival*

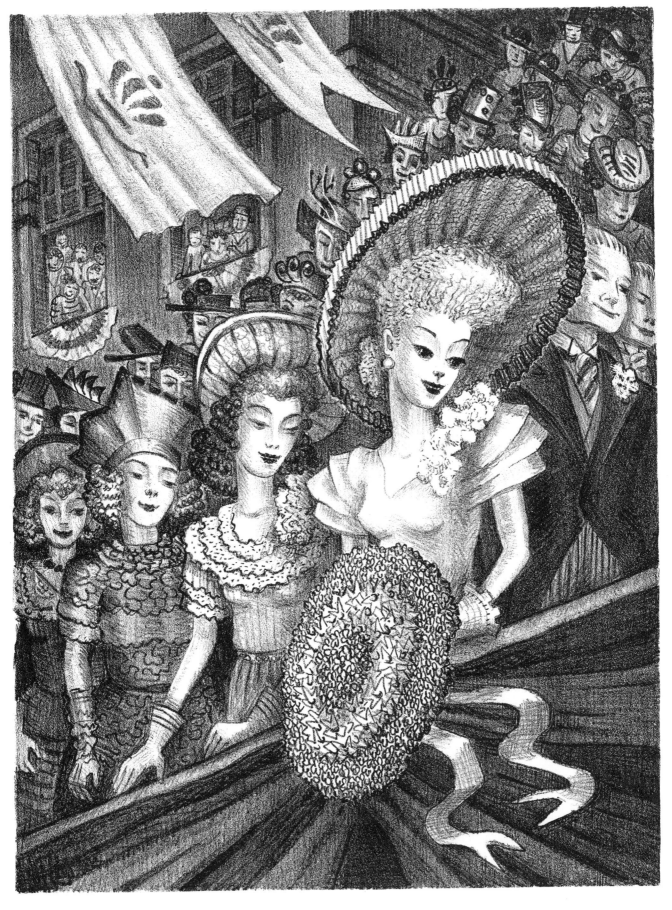

41 *Queen of Carnival at the Boston Club*

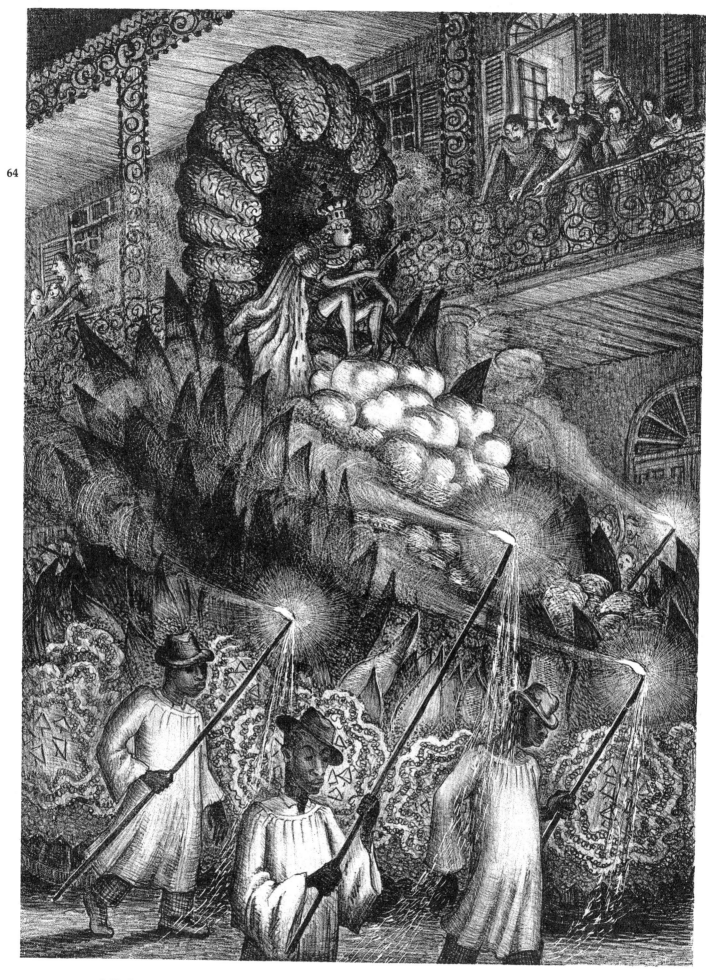

42 *Night Parade, New Orleans*

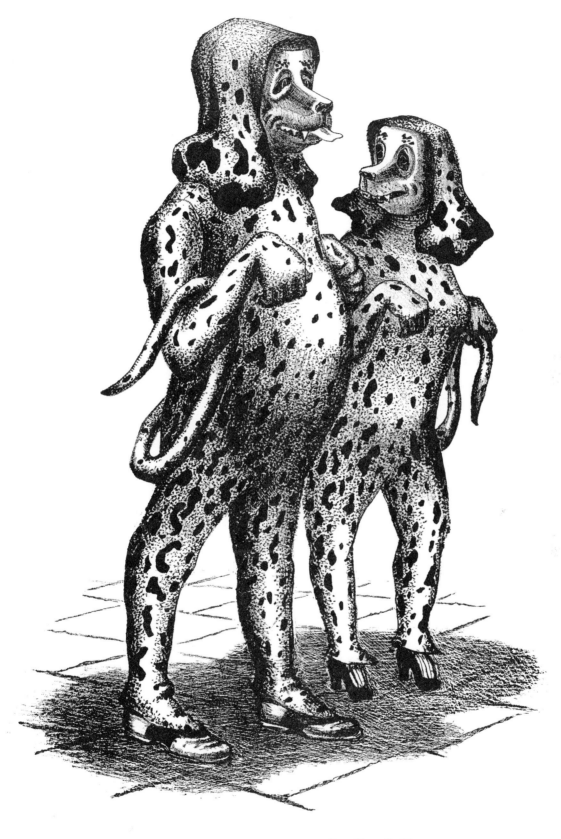

43 *Mardi Gras Day, the Coach Dogs*

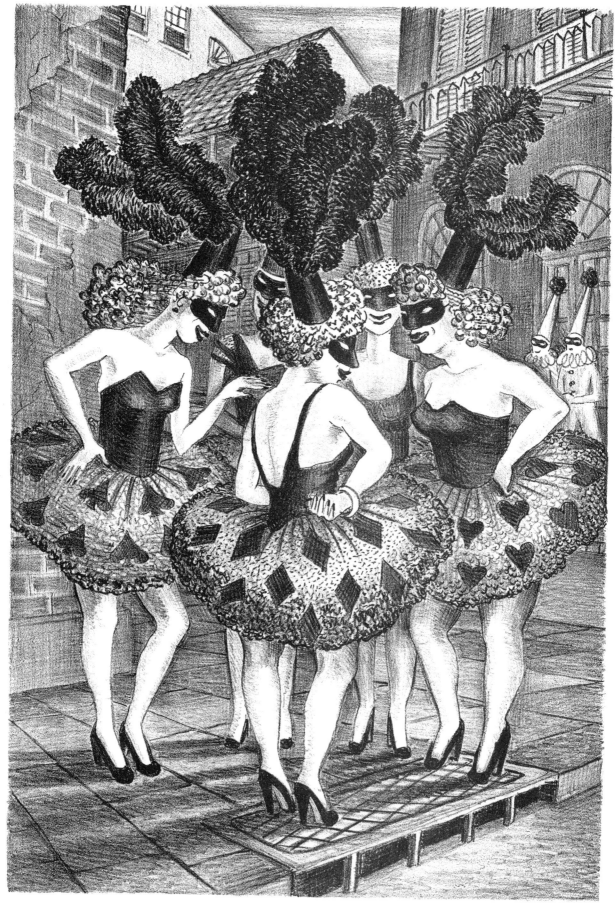

44 *Mardi Gras Day, Five Girls*

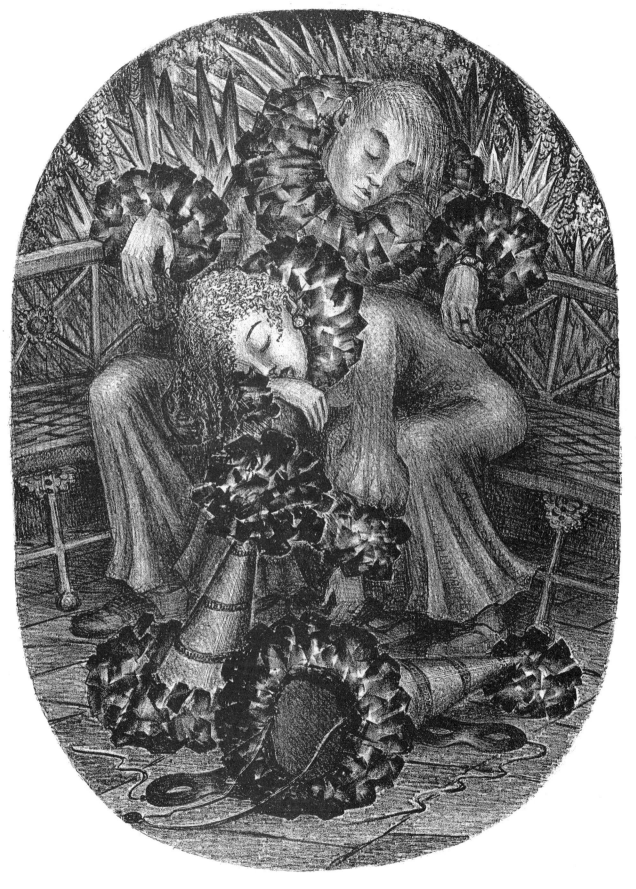

45 *Six O'Clock, Mardi Gras Day*

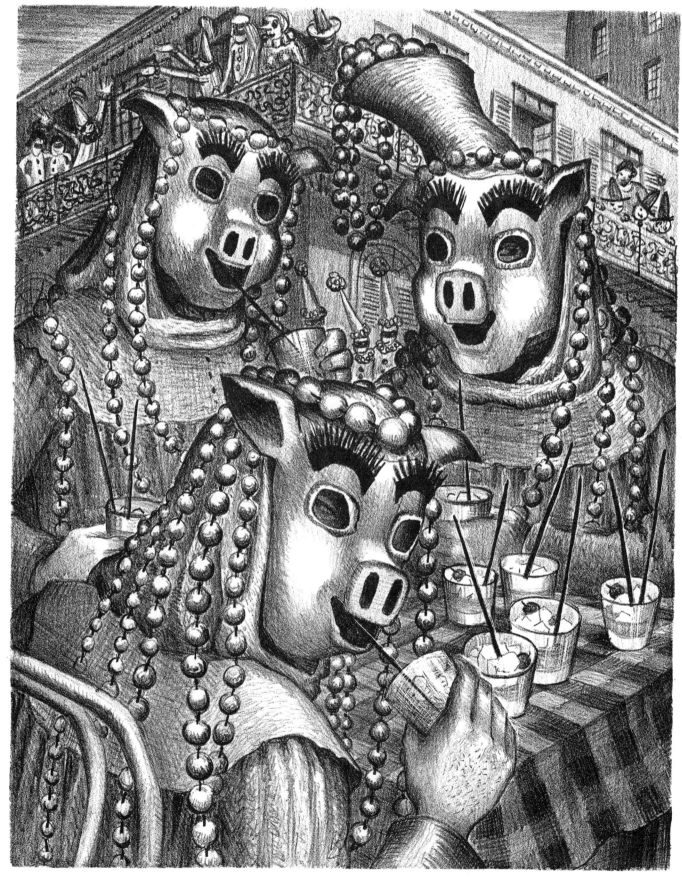

46 *Three Pigs—Mardi Gras Day*

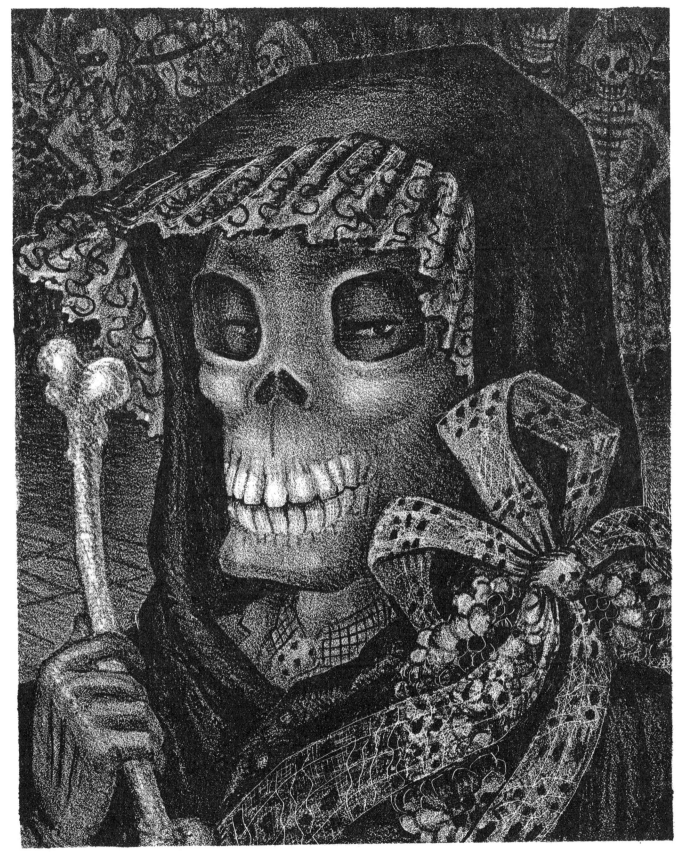

47 *The Death Masker—Mardi Gras Day*

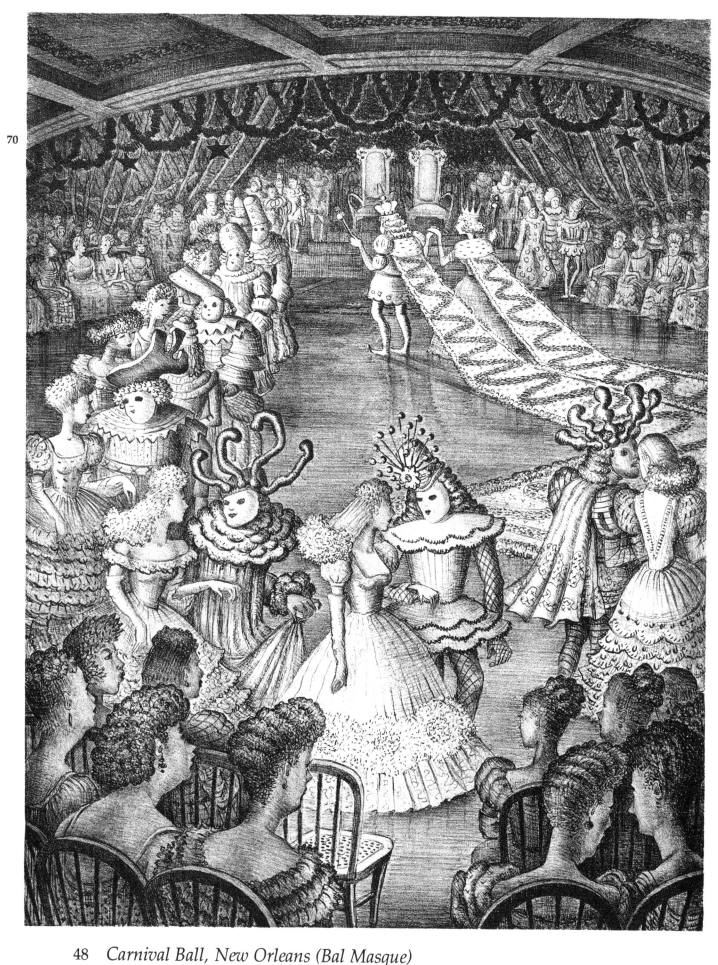

48 *Carnival Ball, New Orleans (Bal Masque)*

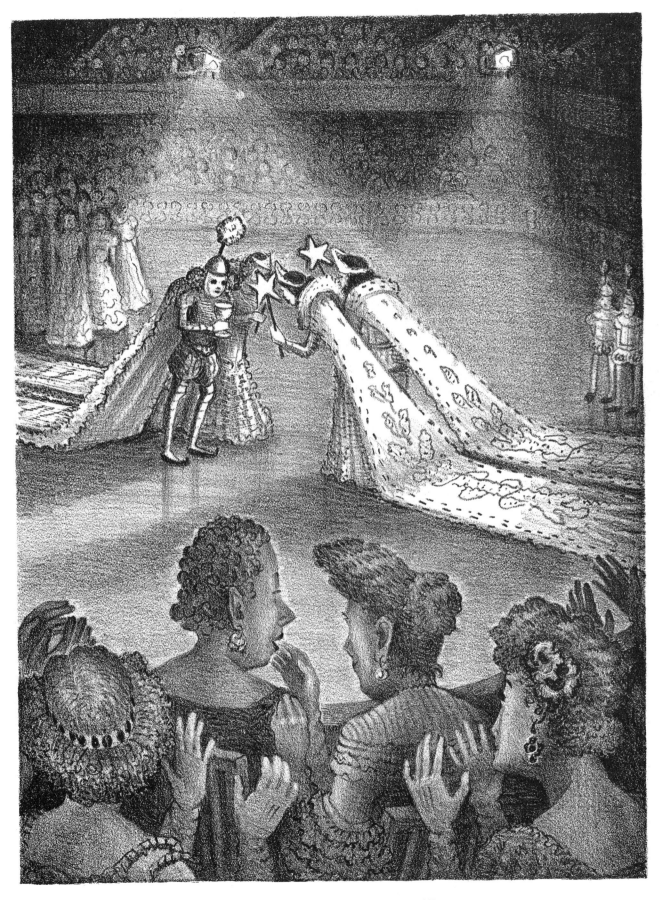

49 *The Meeting of Comus and Rex (Comus Ball)*

masses of *Persuasion* who allow themselves to be raked into the grip of totalitarianism "like a pile of dry leaves" symbolize the inertia of many Europeans who came under the control of Fascist and Communist regimes earlier in the century. Durieux also fretted about the fragile human condition in *Fear*, where two ordinary citizens epitomize the all-pervading fear of modern warfare. A passage from Cervantes partly inspired this image: As Sancho Panza says at one point to Don Quixote: "Fear has many eyes and sees things underground and much more above in the sky."[2] Durieux implies that for many people facing the new terrible set of political realities, trusted ideologies like Christian faith did not hold as much prospect for deliverance as in the past.

Ridicule of people's gullibility (Hitler had persuaded Germans of his program and come to power constitutionally) remain in these new lithographs. But the satire is no longer rooted in comedy. The threatening issues of the 1940s seemed too grave for comic treatment. People at masked balls and on the golf course she could laugh at, but the imminent collapse of Western Civilization was not amusing. Durieux's draftmanship in *Persuasion* and *Fear* is high-strung. The subtle gray tonalities of the comic prints now give way to blackened areas that create sinister effects. Gone are the clear, clean lines, tight boundaries, and generous arenas of space; instead, the viewer finds freer, choppy, crabbed blacks and whites that run over into the other's territory within a shallow, almost claustrophobic space. The thick, velvety ground of black ink appropriately captures the nocturnal menace of these imaginary scenes. The downcast heads and bent-over bodies of the victims in *Persuasion* reinforce the gloom of this dramatic lithograph. As a whole these works of the tragic spirit relate to those grim, frenetic drawings of the aging Daumier who poured out all his bottled-up disappointment and indignation in the decade (1866–1871) of the Franco-Prussian War.

The downcast tenor so evident in *Fear* and *Persuasion* was not entirely a new departure for Durieux. She had on occasion suggested an ominous side to the New Orleans milieu in prints like *Desirée* (1947, figure 55) and *The Visitor* (1944, figure 57). The death figure in *The Visitor* is not another grotesque masker loose during Mardi Gras. Death through the postman delivering that telegram, "I regret to inform you that . . ." was an omnipresent reality to families on the homefront in World War II. Caroline relates how the idea for this symbolic satire came to her at a cocktail party in the French Quarter of New Orleans during the war. "It was one of those smart gatherings of Army and Navy 'brass' and many well dressed women. Every now and then the conversation touched for a moment on the reality of war and quickly left it. 'Where is John now?' 'Well, we lost him at Saipan.' 'Yes, I heard about Joe, it was at Guam.' I felt that death had been invited to this party and was coming."[3] In this bittersweet

2. Durieux, "An Inquiry into the Nature of Satire," 29.
3. *Ibid.*, 27.

74

image, Durieux placed a ludicrous transparent evening gown over the skeleton to evoke the seductive rather than the reaper specter of the final reality. The comic and the tragic also intermingle in the poignant 1947 lithograph, *Desirée*. Her spirit is worn down and even her physical charms are spent as the lumpy body, sagging jaws, and tired eyes tell us clearly. The incongruous touches—the pretty flower in her strawlike hair and the delicate ruffles sewed on the ill-fitting dress—cannot permit this French Quarter prostitute, the object of desire, to cheat the inevitable beat of time.

Gradations of black and white evoke the twin tragic-comic mood of *Desirée* and *The Visitor*. In only one print of tragic theme, *Children* (figure 56), did the light tonal values predominate. And as Durieux notes, this stylistic reversal was an integral part of the irony of the print, meant "to suggest at first glance that something pleasant" or sentimental is about to be said of the children. In fact, "these are not really children their eyes are old from seeing too many unchildish things and what they are looking at is not stated, it is implied. The deception enhances the cruelty of the satiric comment."[4]

There is a tradition that the "impulse to satire stems from some inferiority or dissatisfaction in real life, that . . . satirists are thirsting for revenge."[5] Applied to Durieux's art this statement is only partly true. She was never embittered about life like Goya and Grosz. Durieux was an artist twice blessed with a fascinating Creole heritage and an understanding husband who provided her with travel opportunity and physical comfort at a time when other artists were struggling to find their next meal during the Depression. Her satire has wit and generosity as well as stinging criticism. She is more in the tradition of Daumier—no one was more well-adjusted than this French satirist—and incorporates the roles of entertainer and reporter as well as cynic and propagandist into her art. Still, she does possess a grim side that emerges throughout her career as she surveys the corrupt state of world affairs. *Tomorrow* (figure 58) is the most abstract, symbolic lithograph of the tragic-spirit series. It is stripped of all setting and narrative. These two figures, who seem to petrify before our eyes, represent humanity that can seemingly become immobilized when faced with the awesome task of solving problems in modern life.

4. *Ibid.*, 24.
5. Zigrosser, *The Artist in America*, 129.

50 *Persuasion*

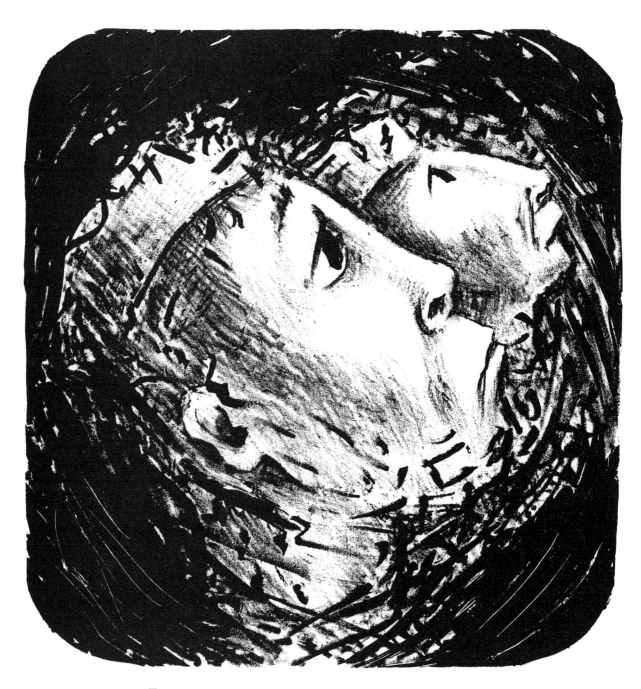

51　*Fear*

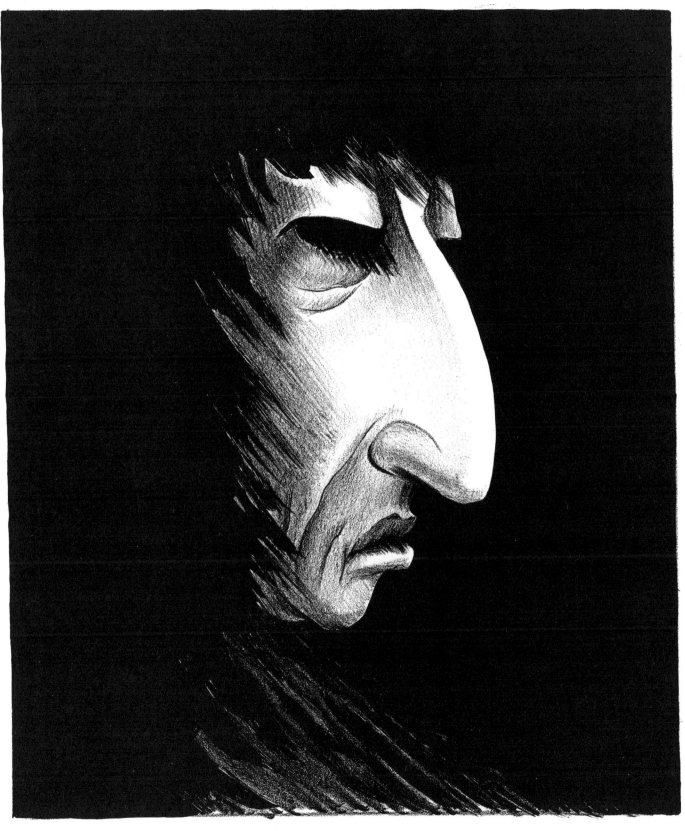

52 *Exile*

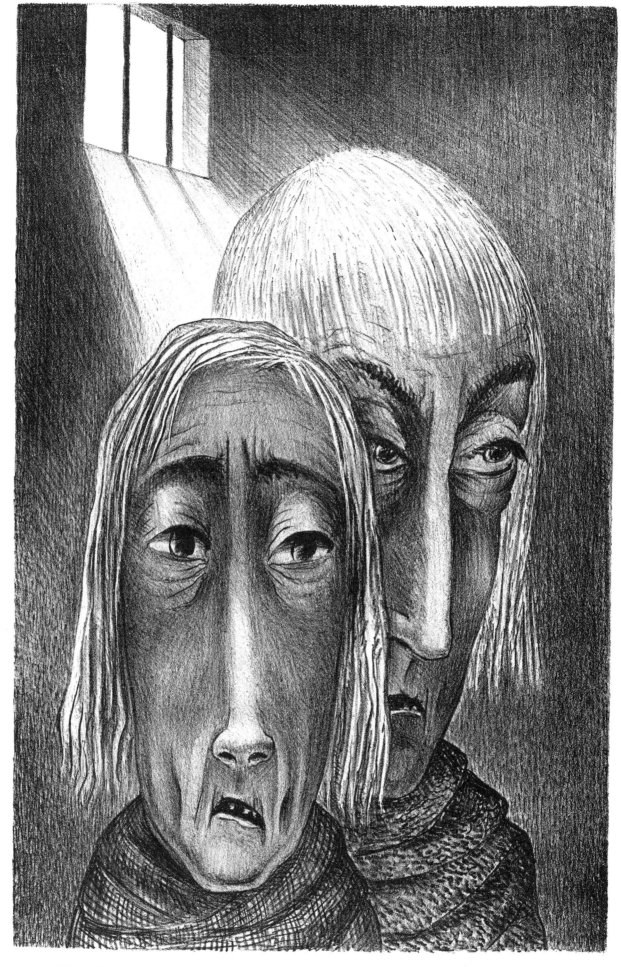

53 *Oppression*

54 *Survivor*

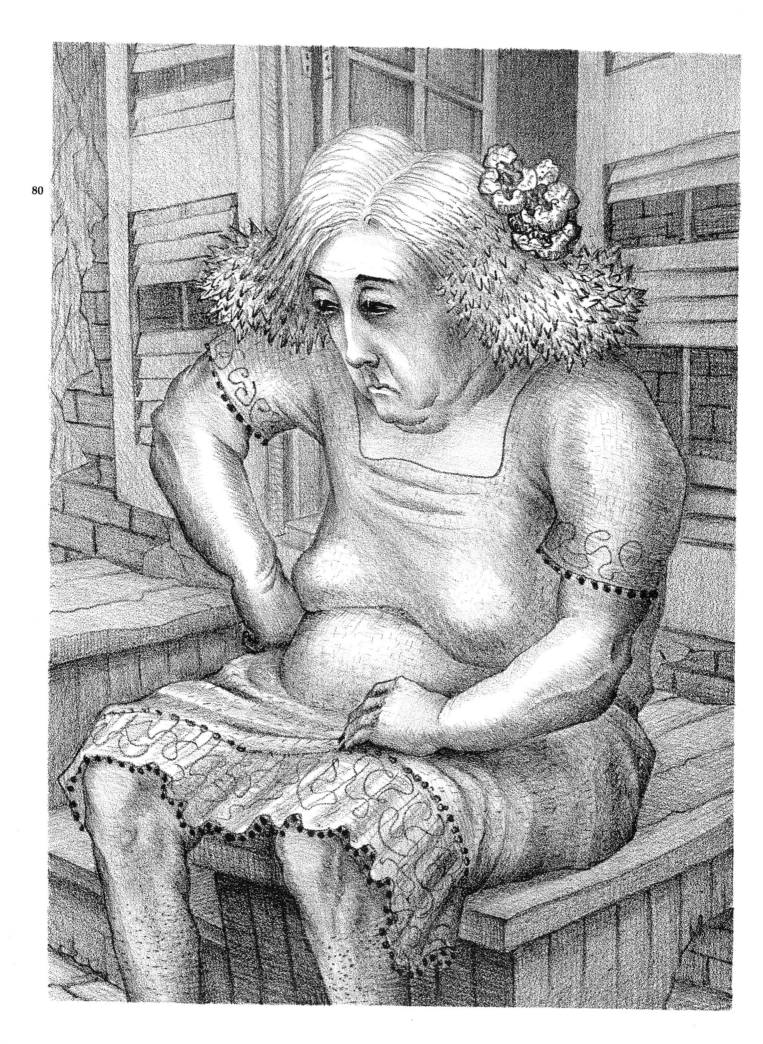

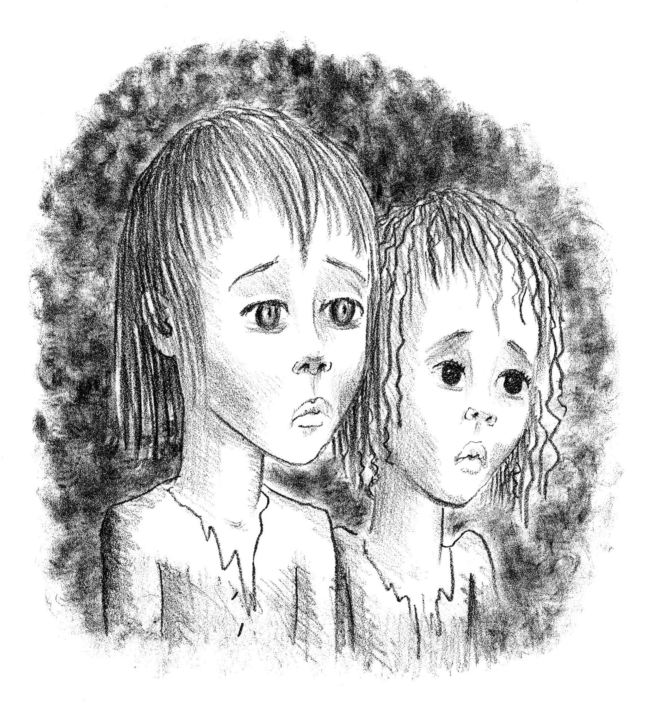

56 *Children*

55 *Desirée*

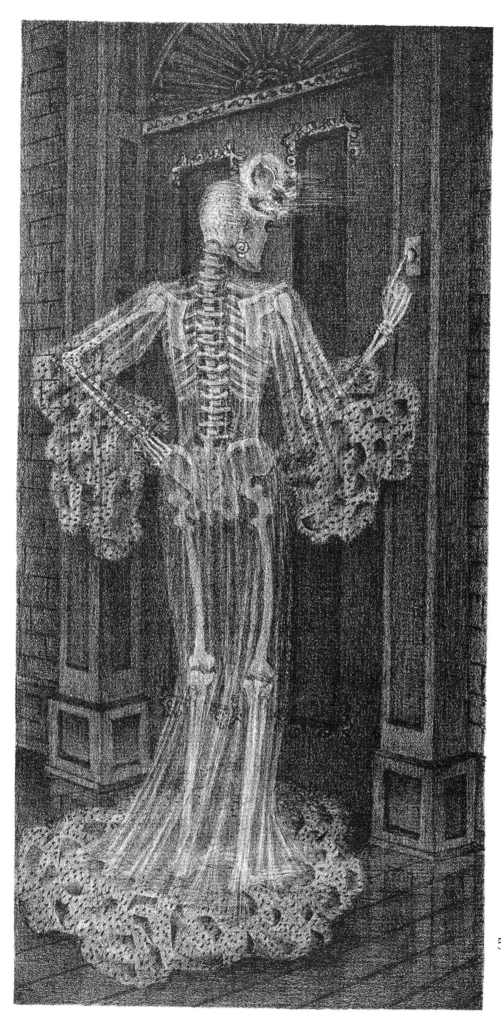

57 *The Visitor*

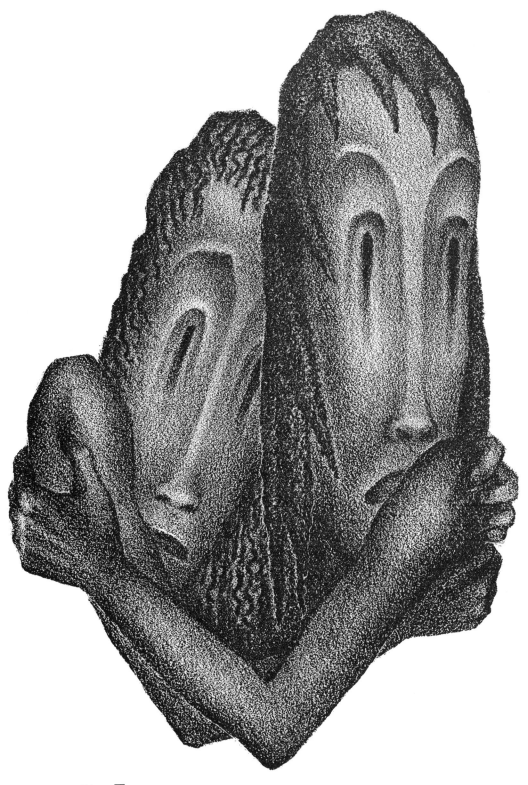

58 *Tomorrow*

Caroline Durieux